Sited *Body*, Public *Visions*
silence, stillness & walking as **Performance Practice**

Ernesto Pujol

For my students, past & present

Printed by Amazon Books
First edition funded by *The Listening School Project*
Cover and book design by Joseph Waller
Image processing by Greenberg Editions
Edited by John Alan Farmer
Reprint by María de Mater O'Neill, Rubberband Design Studio

Copyright © 2012, 2022 by Ernesto Pujol
All rights reserved.

ISBN 978-1-938-02208-1

All images by Ernesto Pujol, unless otherwise noted
Front cover: *Lost (America)*, digital image from *Inheriting Salt*, Salt Lake City, 2007
Back cover: *Mother of All Souls*, digital image from *111 Days in Deseret*, Salt Lake City, 2010

*Walking for no purpose, other than
walking without regard for time; no
food-hunting, no water-seeking, no
conquering and enslaving, but only
walking for the sake of seeing in silence is
the gesture that publicly marks the birth
of human consciousness.*

Acknowledgments

This performance text owns its existence to curator
Mary Jane Jacob, The School of The Art Institute of Chicago,
artist Janine Antoni and writer Carol Becker.

I wish to thank Saralyn Reece Hardy for her guidance,
John Jaspers for his untiring dedication to the medium,
and Matthew Goulish, Peggy Phelan and Rebecca Solnit
for their performative writings.

Grateful acknowledgment is also given to my editor,
John Alan Farmer, for his generosity and sensitivity,
my two readers, Elaine Angelopoulos and Noémie Solomon,
and all individuals and institutions mentioned
who contributed toward this text.

Finally, I wish to pay homage to the writings of
Christopher Isherwood and to Walt Whitman's *Preface*
to his first edition of *Leaves of Grass*.

This is a work about the end of time.

	Introduction[s]	9
Part 1		
Chapter One	*Early Bodies*	17
Chapter Two	*Psychic Bodies*	39
Chapter Three	*Eating Performance*	55
Chapter Four	*Vulnerability as Methodology*	83
Part 2		
Chapter Five	*Absence Through Presence* [*Chicago*]	103
Chapter Six	*Walking on Water* [*Boston*]	125
Chapter Seven	*Becoming the Land* [*Salina*]	149
Chapter Eight	*Speaking in Silence* [*Honolulu*]	163
	Postscript	183

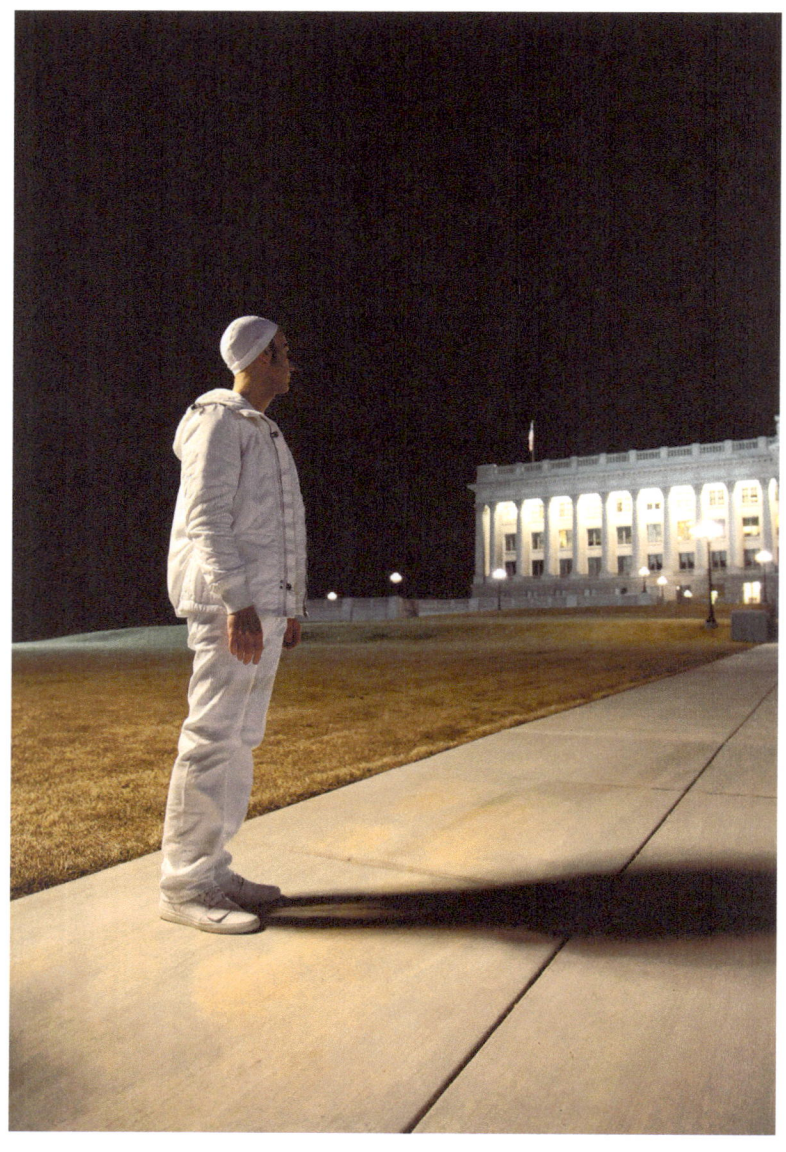

Awaiting performance, digital image by Colin Roe Ledbetter, Salt Lake City, 2010

Introduction[s]

a. *Revelations*

It takes the passage of time, sometimes a lifetime, for an art practice to mature, to know itself, to reveal its secret depths and complexities, admitting to the psychic, in the Jungian sense. Over time, I have become a site-specific performance artist and social choreographer. I conceptualize psychic portraits of peoples and places as durational group performances. I can admit to this now. In the tradition of American itinerant portraitists, I X-ray communities and their landscapes, revealing what is under their skin and surface. I carefully expose the secrets that remain unarticulated, the wounds that must be aired, that must be healed for the survival of these communities and landscapes. I am a metaphor-maker, striving for poetic subtleties as audience-welcoming strategies.

b. *Thisness*

This is not an academic text about history and theory. This is a text in two parts. The first consists of a history of my body as an intimate memoir that reveals the vulnerable basis for much of what I do. The second consists of sample field experiences for education and future reperformance purposes, followed by postevent reflections. When I began to write, I called this book *Body Walking No-Where, stripping the performative body*, combining two phrases I often use when training groups. In the end, I gave it a more transparent title and subtitle beyond insider codes. The final text encompasses a wide range of writing styles, such as childhood memories and dreams, adult anecdotes and journal entries, correspondence with artist friends, descriptions about my public (social) and private (interior) practices, the sighting of spirits and the casting of spells. They are not presented in chronological order. They go back and forth in time the way our minds dart between past, present and future. Thus, the entries can be read randomly, and the chapters are freestanding parts.

I am an eclectic reader. I am not a wide reader, but an intense reader. I always seek primary sources, autobiographies and writings by artists about their mediums, such as Yoshi Oida's thoughts on cleansing the body's nine holes, on knowing the geography of the body as a prerequisite for movement. As Peggy Phelan elaborates in *Mourning Sex: Performing Public Memories*, performative writing seeks to actively reveal the unseen forces behind a performance practice, inviting action from the reader. It is a genre that urgently seeks immediate agency. Thus, I share these texts as a space of innocence with professional performers and performance-art students seeking support for their efforts toward silence, stillness and meditative walking. The admission fee is sincerity, the tax is self-criticality and the ticket is compassion.

c. *Kouros*

I am a walker by profession. I walk alone; I lead walks; I watch walkers walking. And I am always struck by how unaware most people are of their walking while walking. They are hardly ever aware unless some part of their body hurts, suddenly casting light onto uncooperative dragging parts. Some people walk as if they owned the sidewalk, as if they were crossing their living room to get a glass of water, completely unaware of other bodies. Publicly shared body-space and body-flow are alien concepts to them. I am tempted to think that they are very self-involved minds, individuals who live in their heads to the point of pedestrian blindness. This is not about cell phones; this has been unfolding long before their advent and will worsen when people have devices electively implanted under their scalps. Dodging and scanning moving obstacles, I walk as a reader of pedestrians. I quietly perceive everything there is to be known about humans from how they move. It is all there, in their posture, gaze, speed and steps.

d. *Ecphonesis*

Industrialism, advertising and consumerism transformed most contemporary art into sculpture by the late twentieth century. In the twenty-first century, the Internet is transforming everything

into performance. Everyone is performing for the world to watch through Facebook, YouTube and a myriad of webpages, freely available 24/7. So please repeat after me:

1. *Everything is performance!*
2. *Everything is performance!*
3. *Everything is performance!*

e. *Practice*

Silence, stillness and walking practices as performance art. They need not be about macho endurance, about punishing the self and others. In my case, they are strategies toward mindfulness and signs of mindfulness. They are tangible destinies that open intangible destinations. There is no one way to engage and achieve them. In the spirit of Jiddu Krishnamurti, silence once engaged is both an end in itself and a pathless path in every direction.

f. *Breathing*

> Some tragedies should kill us.
> All should stop as we die,
> watching in awe.
>
> But the body insists
> on breathing.
> The living-dead
> must perform life
> until it finds them again.

g. *Reperforming*

You are dead. You are reading this, but you are dead. You died long ago, but you are being remembered. A child is remembering you. In my case, she is the daughter of a friend. She is currently seven years old but still remembers me as the adult woman she became. She liked the fluid outline of my body and its features: I had tattoos and big ears. I brought her little gifts: a collection of miniature cacti and

succulents for her birthday; a life of the Dalai Lama as a graphic novel she colored; plastic sea animals in a pouch for no reason other than to make her smile.

I am a memory. You are a memory. We are now part of the same eternal body, you and I, whoever you are. There is no time and time is simultaneous. Our past, present and future have come and gone. Our past, present and future are here at the same no-time. We achieved, and we did not achieve. Our bodies grew tired and weak, sickly and ill. We died and life proceeded. I am a memory in the mind of a child turned adult. And she, in turn, is the memory of someone I may never know. We see, we are seen, and the seers are seen, multiplying as through mirrors. At some point, I'll read about me without knowing it was I. I mourn this, and I let this go, detached. I am your body. You are my body. I have no body, and I will always have a body.

I give you all my past bodies so that you can remember yours and be freed to perform new ones.

Part 1

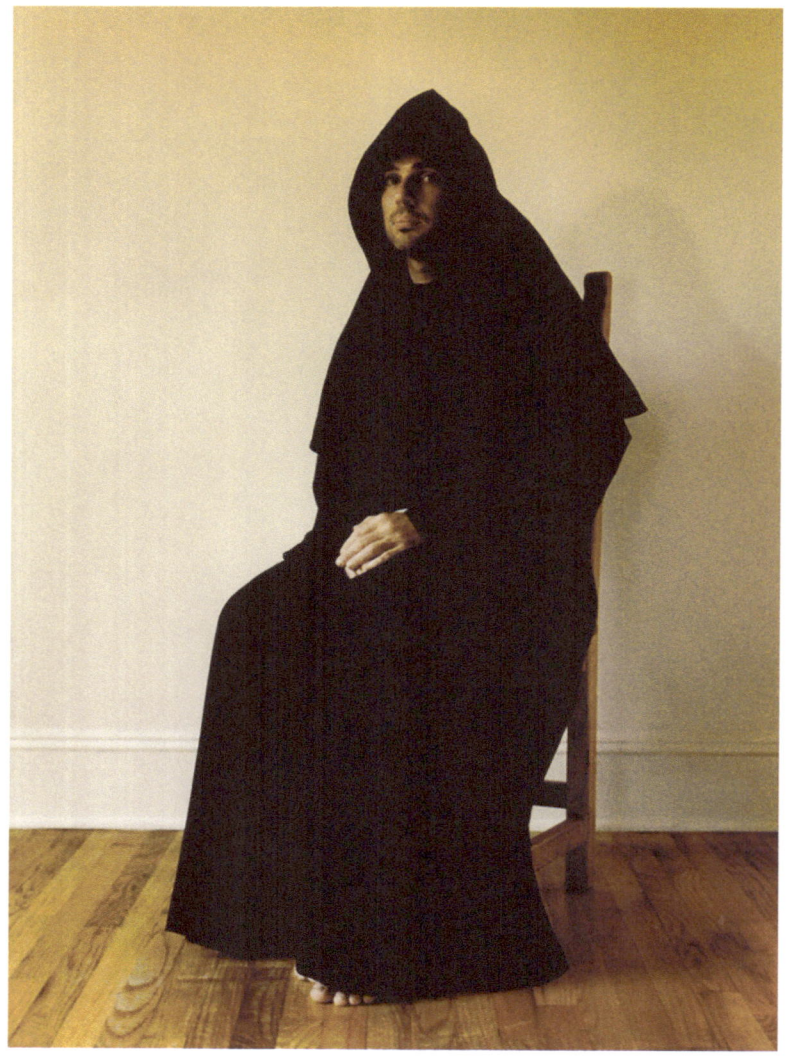

Seated Franciscan (Detail), C-print from *Conversion of Manners*, New York, 1998

I have a daily body practice. I ask my body: How do you feel today? What do you want to do? Where do you want to go? And I listen, trust and follow it humbly.

Chapter One *Early Bodies*

A Child's Body 1

Enchantment was the earliest form of medicine, spirituality and art, all in one, indistinguishable. As a child, I believed that my body had special powers. Among them was my ability to make rain by secretly willing it. I hated hot sunny days and longed for cool rainy ones. I was a child of the shade, moist moss and wet ferns, of secret walled gardens. The sunniest day would dawn, and I would desire rain, conjuring it all morning, smiling to myself, confident that no matter how cloudless it was, my wish would come true. And, sure enough, some time late in the day it would suddenly cloud up, and a big downpour would ensue. I was so confident of my powers that I remember telling my mother, boasting about it in the middle of an impossibly sunny day, complete with beautiful blue skies and puffy white clouds. My mother did not believe me, of course, and thought that I was extravagant. Regardless, I kept assuring her that it would rain, and it did. But while my pragmatic mother dismissed it as an unexplainable coincidence, I regarded it as the undeniable confirmation of my body's secret powers.

Over the years, I gradually stopped the rainmaking, as the magical world I inhabited increasingly drew within. Did my powers go away? Did I ever possess them? All I know is that it rained when I asked for rain. My child's body had special powers because I believed it had special powers. I had a boundariless body connected to sea and sky. Now, I believe that I still have special powers but of a different kind. As a performer, I can be silent for hours and make people slow down, stop, become silent, sit down and ponder life. Perhaps these are greater powers than rainmaking.

A Child's Body 2

Another of my early body's special powers (which included visualizing the invisible and dreaming the future) was my ability to breathe underwater. At the age of four, I had a recurrent dream in which I visited an imaginary friend who lived at the bottom of the sea. I would fall asleep and immediately find my naked feet walking on sand along a deserted beach. I would walk into the surf, wading in until gentle waves covered my head, at which point I would continue breathing under water. There would be no interruption to my breathing process; it was continuous. I would walk for miles until it got dark because the sunlight barely filtered to such great depths, at which point I would begin to see dim lights in the distance through fields of tall algae. They were the lights of the *mer* city where my *merboy* friend lived. I dreamed this until my friend died tragically, at which point I tearfully ran back to dry land never to return. Yet to this day, whenever I find myself submerged in a pool, I still do not understand why my body does not breathe under water. I still believe I posses a secret amphibian body. For years, I would hold my breath and swim to the deepest part of a pool hoping that my underwater-breathing ability would activate itself, like something dormant awakened in recognition of water.

Exiled Bodies

My grandmother and her sister, my great-aunt, became political exiles in their sixties and were unable to start new lives, so they spent the next two decades remembering their former ones. I called them memory machines: old bodies enthroned on rocking chairs revisiting stories from an epoch that was long gone before communism took over their country. My grandmother and her sister grew up on a palm plantation outside Havana at the turn of the century. Their late Victorian memories (as everything arrived late to the colonies and lingered) informed my late childhood body. There was a period when I did not know where their memories ended and my own memories began. In my mind, my body had lived on that plantation. My body had been there, secretly, invisibly, but no less physically. They were so detailed in their descriptions

(often accompanied by antique photographs) that I experienced memory flashes of the smells and tactile experiences of that rustic environment.

Nevertheless, having lost everything, there was a heartbreaking passivity to their bodies. They embodied surrender and defeat: a series of arms-down depressive gestures that no beautiful mahogany rocking chairs swayed by cool trade winds could blow away. The *body of exile*, in their case, was devastated and inert. The mind took over to remember while the body waited for death as release.

My parents, however, were young bodies of exile that had two jobs each, as both worked nonstop to support their elders and children. They had slender bodies that took long weekend road trips across a new adoptive country, kids thrown in the back, getting away from the old sad bodies at home. My child's body was tossed in-between, sitting at the foot of elderly women's bodies, listening to their accounts of a mythic past, and carried and driven around by my youthful parents' bodies, plowing ahead. In the end, my grandmother and her sister died far away from their homeland, their exiled bodies wishing they had never walked away from that ground, their ashes sadly scattered by my mother under Flamboyant trees.

Witnessing their tragedy, early on I learned the value of walking. Walking is a powerful symbolic act. One should try to be prescient about it, considering its possible short- and long-term effects, often irreversible.

Inherited Bodies

My body inherited a disappointed view of the world as expressed in a repertoire of gestures. I inherited the indoor physique of disappointment. In addition, my body was formed by my elders' Roman Catholicism; it was shaped by their suspicion of all things worldly. They were practically neo-Medievalists, avid readers of Thomas Kempis's *Imitation of Christ*, for centuries the monastic manual of devout Catholics who regarded the world as a valley of tears. Thus, my body has endured a lifelong struggle with

melancholy. It has always had to fight an ingrained tendency toward paralysis, which I have worked to transform into silence, stillness and meditative walking, the hallmarks of my performance practice. Magicians transform curses into blessings.

Over the years, melancholy has become like an inch of clear water in my basement. I have a slightly flooded basement, but everything is on stilts, so nothing is damaged, drowning or rotting. It is so common for creative bodies to struggle with melancholy, which I distinguish from depression. (I visualize depression as the dark, hirsute, angry, aggressive tumbleweed of chaos.) There is a hypersensitive creative profile that unconsciously senses, that consciously intuits and even absorbs the pain of others as melancholy, even well ahead of time, as if smelling the coming of rain. Melancholy is often a sign of a certain kind of beautifully empathic performance artist, but it must not be turned into a romantic cult. I always ask my performance students what kind of bodies they inherited. Are they aware of this inheritance?

An Elusive Adult Body

In spite of this archetypal inheritance, I was a very lively child, always singing, dancing and telling stories. But as I grew older, my body became distant, even alien. My body was the great forgotten. I ignored my body, sometimes not looking at myself for days, forgetting what I looked like, suddenly catching glimpses of myself in a store window and being surprised by my reflection. I had forgotten my face; I was surprised that I had such a face. As mentioned before, I was trained in Christian duality, in the warfare between the body and the so-called soul over a single lifetime; and I chose the soul, hoping to transcend the one-chance body. In addition, I did not attend a high school with a gym program, so there was never any healthy physicality or uninhibited nakedness during my education. Later, in a monastery, there were only penitential bodies covered by symbolic robes-as-shrouds. Cloistered Christians perform a death-to-the-world expressed in efforts at disembodiment.

Not even in the gay community did I discover my body. There were only neocolonial projections by partners who fantasized my tanner body as passive or dominant bedroom spectacles.

If the angel says that *The Body is the Garden of the Soul* in Tony Kushner's *Angels in America*, the Pulitzer- and Tony-winning drama by my favorite playwright set during the Reagan years, I did not know this for much of my early life. I finally found my elusive adult body through performative photography and live performance art. It felt shockingly late, but I have to remind myself that the creative process does not follow a chronological arrow-line pattern. It is a cyclical process, looping back on itself as it evolves deeper, like a whirlpool. The deeper you whirl, surrendering, the more stillness you find, the more freedom. I am a late bloomer in every area of life that concerns being a holy animal. Nevertheless, I can now trace a history of my individual and archetypal, material and psychic, archaic instinctual body, in the Jungian sense, as it rose to prominence in my consciousness, to the point of now guiding it fully. Along the way, I have discovered that we experience different bodies, sometimes simultaneously. We have many bodies.

Dancing the Body *Summer 2007*

I used to dance the way other people sing in the shower when no one is within earshot. I danced all the time by myself, with or without music, throughout my parents' empty house. Weekends were particularly danceable, because the family often went to a beach house and I would have our home all to myself. I would dance with long strides, drawing in the air and on the floor with my hands and feet in slow or fast strokes according to the mood and speed of the music. My body responded naturally without any effort. It was raw motion, graceful in its untrained state.

I interrupted my solitary dancing when I moved to New York City. I lived with nosy roommates and no open space. It was not until I found myself living alone in a one-bedroom apartment overlooking Atlantic Avenue in downtown Brooklyn that I began to dance again late at night in the dark. The apartment was newly renovated, its

smooth wooden floor freshly polished. It was above a store, so no one minded the noise after hours. These dances too, however, were short-lived because a new boyfriend moved in and his body was stiff, his gaze negatively critical.

I still daydream about a small household of empathic dancers. Years later, it is only now that my dancing returns in the form of walking. My walk is dance.

The [*Female*] *Body of the City* *Summer 1985*

I arrived in New York City in August 1985 to live and work among the homeless in a Catholic Worker community, the Great Depression lay movement founded by communist journalist-turned-saint Dorothy Day, an American Mother Teresa. I lived for two years at St. Joseph's House, a small shelter for homeless men located on First Street, between First and Second Avenues, in the Lower East Side. The area was being gentrified. For some, it was a cultural renaissance; for Eastern European and Puerto Rican families, homesteaders and punks, it meant looming evictions.

The East Village of the 1980s was home to countless artists, like my former schoolmate Felix Gonzalez-Torres. The neighborhood boasted amazing dance clubs like the Saint, where my body spiraled all night long, probably the only sober dervish on the floor, and the famous St. Mark's Bathhouse. Jeffrey Hill, my first lover in the city and a former dancer with the Lake Erie Ballet, was night manager there and learned more about men's bodies than I ever wanted him to know.

Back at the shelter, the men's grimy bodies were always exhausted and mostly black, reeking of alcohol, in need of delousing. Whatever they wore had to be destroyed. Their body gestures ranged from catatonic to violent. I remember two desperate men having scatological sex in our soup kitchen's filthy little bathroom while we pounded on the door to make them stop, a long line awkwardly standing by.

Nighttime was particularly challenging. I slept in the top-floor dormitory with fifteen men and a million roaches, our bed-bug-infested mattresses a mere six inches apart, the air thick with rancid body moisture. We had to vacate the building during a particularly bad heat wave when all the bugs were out crawling and blast it with insecticide for twenty-four hours. I ended up in hospital emergency rooms twice that first summer, my body having no immunity to the maladies running through the homeless populations I was serving.

My most haunting memory from those city-novice years is that of a homeless black woman begging for a slice of pizza on a busy Friday night along Second Avenue. The waiters from Central America (barely above the poverty line themselves) who worked the pizza-parlor counter refused her, so she offered herself to them. She pulled off her dress and stood stark naked on the avenue while heavy traffic flowed behind her, illuminating her body on and off. It happened so fast that no one could stop her. No one dared touch her as she begged for a slice in a pitiful parody of seduction, with huge droopy breasts, a protruding belly, abundant black pubic hair, a voluminous ass and long skinny legs—an imposing Hottentot Venus.

One of the waiters finally jumped over the counter, picked up her dress from the sidewalk and threw it over her. But she tossed it off and remained adamantly naked. To this day, her body remains

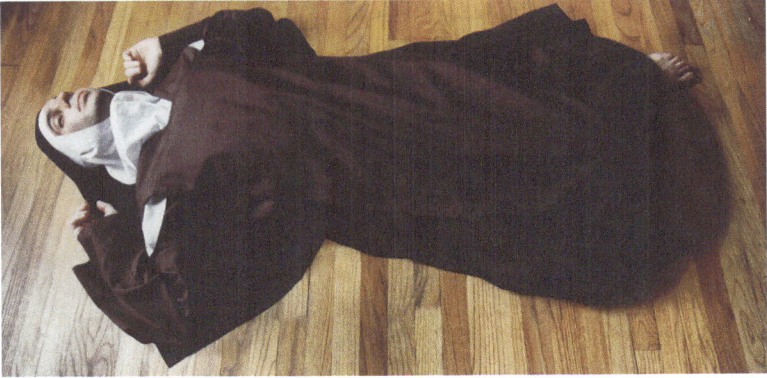

Levitation (bottom panel, triptych), digital C-print from *Hagiography*, New York, 1998

naked on the avenue deep in my mind. That woman was the true body of the city in 1985, with a booming homeless population as money flowed ostentatiously toward the market crash of '87.

The [Male] Body of the City Summer 2007

Yesterday, a young homeless man wearing a Victorian ballgown with a long train hurriedly walked by. He was white, bearded and robust, with long brown hair. He carried a black plastic trash bag with all his belongings. It was the most devastating public drag performance I had ever witnessed. I ran and caught up with him on a busy corner of Atlantic Avenue in downtown Brooklyn. The two of us must have been a tragicomic theatrical sight. *What happened to you?* I said. He looked directly at me, puzzled and apologetic. *It's a long story*, he replied as he shrugged fleshy shoulders. He was friendly but understandably unwilling to share with a stranger. I dug my hand into my left pocket and hurriedly pulled out all the cash I had, which consisted of a bunch of crumpled dollar bills. He was shocked by my gesture and thanked me, visibly touched, but immediately moved on, unwilling to engage in more conversation. I watched him walk away as I too began to move. Having chased him, I did not want to further embarrass him by standing rather dramatically while watching him walk away, calling even more attention to us. I was sure that many had watched our surreal sidewalk exchange. He struck me as a young gay man addicted to crystal meth, and he left me desolate. I was amazed by how my body instinctively wanted to embrace him, as if it knew that talking would resolve nothing. But my arms never had a chance. He was an urban apparition that vanished as quickly as it appeared.

Today, I walked by a second homeless man, but this one was sleeping on the sidewalk. He lay in a semifetal position, amidst black plastic bags filled with clothing. His baggy pants had fallen, poorly held by a string. His hips were revealed, as well as part of his thick black pubic hair. It was both disturbingly attractive and repelling. He was dark with long dirty hair and an unkempt short but full beard. As he turned slowly in his stupor, I was faced with glimpses of his leathery testicles and the root of his thick brown

penis, exposed yet socially castrated. The American male body has long struck me as increasingly disempowered in city and country. I do not desire the return of a domineering American male body because the competitive races, the manipulative games and the tantrums of that irresponsible man-boy's body have caused enough destruction, at home and abroad. The alternative, however, is not a ruined body, the psychic geography of an embodied polarity. A ruined body can rebuild itself through resentment into a war machine, as was once the case with Germany.

There is a disturbingly easy awarding of hero status in America. It results from an unheroic manipulation of the heroic perspective. Suddenly any American male can be awarded an exalted heroic body for merely doing his basic duty, by way of post-9/11 local, regional and national political media abuse of the term. But this only functions as a placebo of sentimentality that ignores a multitude of orphaned male bodies on our streets that are mutilated, unemployed and stressed. I want a *body of dignity* for the American male, but the source of his newfound dignity must be sited beyond capital and war.

Soldiers' Bodies June 19, 2007

I write this during wartime, during an undeclared war, like so many of our informal American wars, only this one has the epic qualities of a neo-Crusade. Even if it is rushed to closure by the end of this first decade, its physical and psychic effects will haunt us for a second decade, if not more. Our American bodies should make note of that because we will need epic gestures, epic performances, to address it.

I seek to witness disappearing male bodies throughout the Middle East, like contemporary tragic genies, both pale and dark male bodies that vanish, handsome and strong, reappearing dismembered, scorched, lifeless; unrecognizable bodies in news headlines from which individuality has vanished as they are lumped into mere daily counts. I am driven to perform soldiers' bodies, not in their writhing agony or mortuary stillness, but *mourning* for

them the way an out-of-body experience allows you to look at your former body, lying dead in front of you, and experience great loss. Mourning marks the birth of compassion, and compassion extends the landscape of love. Mourning the loss of one's body triggers compassion over the loss of all bodies, even the enemy's, and thus love of the enemy. We Americans need to reclaim the love of our enemies.

Body of Love *December 24, 2007*

Queer art historian David Getsy described my *Memorial Gestures* performance at the Chicago Cultural Center as a form of cruising, in terms of the queering of public space—the experience of encoded walking through space. Although I embraced his use of the term in his generous essay, I also pointed out that not all queer walkers seek anonymous sexual encounters. In many cases, they seek true love. Cruising can be the public statement of gay men's private desire for love, the public witnessing of their profound secret yearnings. These are the yearnings expressed in Walt Whitman's *Song of the Open Road*. The body takes to the universe as an open road toward the unseen, witnessing through presence, unabashedly recruiting the sweet and determined. The body seeks generous hearts; the body walks the heart and confidently offers the future that must happen to you, to its audience. For Whitman, the body had a mission as great as the soul.

I have tried hard not to be a Byronic character; a tragic performer. Added to the invisible mantle of melancholy I inherited, I was molested for several years by a small gang of beautiful bullies when I was a student in a private, Roman Catholic elementary school. They were the coolest boys in my class. They constantly harassed me, calling me names and grabbing me in the boys' room. Toilet cubicles were particularly dangerous territory. I was terrorized and developed a fear and hatred of school as a place of torture. I would hold my pee to the point of wetting my pants, to great public humiliation, rather than facing the bullies waiting for me in the restroom. I began to fail all my classes but out of shame never reported what was secretly happening. My mother took me to various child psychologists, but I divulged nothing. Of course, the

male doctors also never asked me the right questions. The system was totally insensitive to bullying, and if it was ever brought forth it is the victim who was blamed. So my body was edited by fear, and it changed. I became an increasingly solitary body standing still in a corner, not wanting to be noticed, yet wanting to be found, all the while looking up at the sky, as high as my eyes could travel, a pose I often unconsciously still perform; a child body pose still embedded in my adult body.

The mind imagines freedom but the body makes it real. My body performs freedom. My body is the playground, the agora (the public square) and the open field of freedom. Human rights give us uninhibited bodies.

Body of Suicide *December 25, 2007*

There is love, and there is *idolatry*. The last time I experienced idolatry during a first date, my body felt heavy, anchored to the spot, practically unable to move. It was paralyzed as if struck by lightning. After our second date, I walked away ill, dizzy, as if I had been kicked in the pit of my stomach, as if I had to throw up. I felt tightness in my chest; I could not breathe. Throughout our third date, my body was both intoxicated and inexplicably light, wanting to land but also enjoying its levitation. I was both physically present and absent, dwelling in an unfamiliar dimension. The next day, my body was anxious, wanting to jump weeks ahead. I was being interviewed by a powerful idol, and I wanted to get done with it and become his priest, even as I resented his cruelty. But because I could not crash through his initiation stages, I felt an inconsolable sadness. I hated my body's material limitations. I walked around wanting to cry all the time. I trusted and feared; I sought closeness and flight. I did not know how long this tortured state would last. It was almost unbearable. It was so extravagant that I questioned its reality. In the end, it was an ephemeral reality. Idolatry left me destroyed.

The body of suicide takes many forms. During a challenging adolescence, death seemed like an attractive door to a dimension much more promising than the hell I was experiencing daily. After

the end of an idolatrous relationship in which I worshipped my partner, there were many moments when I thought that I could not take the pain any longer, and suicidal ideation flooded me for the first time in decades. But rather than suppressing it, I consciously allowed myself to feel and visualize it, studying my suicidal thoughts the way I consider new concepts for a performance.

I believed it important to experience and explore the full depth and breadth of my feelings, no matter how unbearable the pain, how potentially destructive. I was learning about my capacity for feeling, about my capacity to love again as an adult. So I dared to walk to an abysmal edge and look down into its desolate depths. Few wanted to hear this; my friends were shocked. They thought me far more intelligent and spiritual than that. It was humiliating to be witnessed by my loved ones at the center of such a vortex. But I am committed to reality; I needed to know just how sad I was, even if sad enough to commit suicide.

In the end, I lived because of unenlightened and enlightened reasons. I lived because of my foolish hope that my former lover would reconsider. I lived because I did not want to curse him with my death, making him a pariah among our friends. I lived because ending life as a reaction over not getting what I wanted was narcissistic, the kind of entitled masculinity's fatal tantrum that I have always critiqued. I lived because my heart sounded out its depths, grew larger with scar tissue and came back stronger than ever. I lived because I read the news: there were far worse things happening in the world, and there were heroic people with fewer resources struggling bravely against them. I lived because I had public projects to finish; much was entrusted to my care. I lived because I have intelligent, understanding, generous, solicitous friends. I lived because I had dogs to feed, pat and walk. I lived because I knew that we cannot force someone to love us, so ultimately we were not meant to be together. I lived because the body is sacred and I am sworn to protect all life, including my own.

It was transformative to almost-die, to fantasize driving my bike to the East River, parking it along the waterfront, walking into its cold

waters, wading, floating, being carried away, going under, going numb. In the end, it was the rest of numbness that I wanted, but not forever. I lived because the performance of survival is the most beautiful; the *body of survival* is the most beautiful.

Body Positive

I had a public life a decade before my public performance practice. During the late 1980s, I was the founding director of social services for the Brooklyn AIDS Task Force, for which I received a 1989 Michael Hirsch Award from Body Positive, New York, for distinguished service to people with HIV. I was also a consultant to the AIDSCOM Project, Academy for Educational Development, Washington, DC, from which I received a Breakthrough Award for Creativity for HIV-prevention education in South America, and the Diego Lopez Award from the National Gay and Lesbian Task Force for the same.

I had been dissatisfied with my art education and sought to gain control of it by providing myself with an alternative training, starting in the mid-1980s as a case worker for the first New York City Welfare AIDS Unit, walking through African-American and Hispanic/Latino working-class neighborhoods throughout Brooklyn, a job few wanted for fear of contagion. Countless artists, like my colleague Gregg Bordowitz, were bravely involved during those critical years regardless of the safety of their bodies. My last gesture on behalf of the body positive as that decade came to a close was serving as director of the HIV/AIDS Information Program for Latin America with the Panos Institute, London. During my years of service, in-between my undergraduate and graduate art studies, I primarily served gay and bisexual men in the Americas who also struggled with migrant status, poverty and racism. My experience of the body positive was never the Manhattan, white, middle-class population initially profiled in mainstream media. Nevertheless, regardless of race, ethnicity or class, AIDS had a very specific body in the late 1980s, a wasted and wounded body similar to World War II concentration-camp internees.

I remember the guilt of the men who did not become HIV positive; the guilty survivors of the plague. For a while it seemed like they would be a minority, so that negative bodies were lonely. Some sought contagion, seeking to join what then seemed as the one gay body. I live surrounded by a generation that has not experienced the body positive as a death sentence. I am grateful that my body remains negative in spite of close calls through men who were unfaithful to me. I know how health can be lost from one moment to the next, temporarily or permanently, becoming the entire focus of one's life.

Natural Body Summer 2007

This morning, I walk through a coastal wetland northwest of San Juan. It is a fragile ecosystem reclaimed as a nature preserve by the Conservation Trust of Puerto Rico, where I serve as an interdisciplinary curatorial consultant. This is a rare site because coastal valleys are the most colonized areas of the Caribbean. But this is not and will never be a park. This place is deadly if the human body is not in tune with it. The best way to experience it would be to strip naked, cover yourself with mud to smell like it, sniff the air, touch the ground, look around, listen. My body instinctively wants to revert to a prior state in human development to walk through it. Every pore is alert.

Nature offers no nurturing to the alienated body; it is not kind to the disconnected human. Nature will kill this body if it can. We have pretended to live as if there were an inside and an outside to nature, a negotiable distance. Our bodies have always been nature, of course, but our foolish minds have been wandering for over two thousand years enacting a pretentious performance. Yet, reintegration is not about mastering either a painted-warrior survival training manual (that is a patriarchal notion traceable to the hyper-masculinity of early modernity), or achieving a romanticized state of beautiful, minimally costumed balance. Reintegration results in a messy body somewhere in the middle.

Nevertheless, in this wetland, I reclaimed my instincts. I welcomed

the so-called irrational; I reclaimed myself as an animal. I was no more important than an animal. I no longer needed to know everything, even as I felt that I was a part of everything. I knew that my knowledge was and would be different from that day on: I stopped being the center of the known universe. I may have been made from the dust of stars, but I did not need to be the son of a god to feel safe in the universe. I accepted my appearance, rise, fall and end. I realized that if my body could perform outside of the perversion that we called polite human society, it would attain a holiness unknown—an unfamiliar, perhaps disturbing, ancient-and-new holiness as determined by nature. I was horrified by how animals often ate each other alive. I grieved over the lack of protection for the orphaned, the weak, the sickly and the old in nature. But nature remained my paradigm because of its lack of perversity.

Holiness resides in the body. I want to be a *holy animal*.

Tattooed Bodies Fall 2007

Contrary to public assumption, the tattooed body does not love pain. The tattooed body loves artful ink, and makes peace with the electric needle over time. The little burning blade becomes an incisive friend whose sharpness it knows and tolerates depending on the work at hand: the areas of color to fill with a thick needle; the delicate lines to execute with a fine blade.

A tattoo is a revelation. A tattoo is what lies beneath the skin and has decided to surface. A tattoo is the image that was always under the skin, taking a while to form, like personality, like deep complex thought, and is finally public. It is a risk, an admission, a challenge. And sometimes it is a concession to the world. It marks a moment; it signals a personality; it enshrines a life-change, a loss, a dream, a need, a want, a desire, an achievement. It sets a boundary; it dissolves boundaries. It intimidates and invites; it promises and withholds. It is generous and selective.

I began to get tattoos a decade ago, and the more I got, the more they gave me entry into a hyper-masculine world that I

had not previously been allowed to trespass. Tattoos became my unexpected passports into the ethnography of deep masculinity. I suddenly walked through construction sites in the summer, tattoos exposed, and the same rough guys who had previously regarded my body with suspicion, and even sneered, now regarded me with admiration and even jealousy, respectful (and sometimes secretly afraid) of the pain I underwent to get inked. College men, frat boys, suddenly stopped me, asked who did my work and how long did it take? They asked me to reveal my skin, to roll back my sleeves or take off my shirt. They even gave themselves permission to grab and hold my arms, moving them around like tools. I was suddenly a manly man among manly men, an unsought title.

Dog Walking

My old dog died in early June 2011. He was a remarkable Pembroke Welsh Corgi named Scully, a very dark male with a Zorro mask—not the English red that the British royal family favors. During his last year, he hardly walked. I had to carry him up and down the stairs; he increasingly dragged his legs as he tried to walk the streets, hardly able to lift a leg to pee. Scully was an Alpha male, a one-man dog, unfriendly to other dogs (and cats), disinterested in all humans other than me and annoyed by most children, whom he wanted to nip and herd. So I avoided everyone.

I recently adopted a young Australian cattle dog from a kill shelter in North Carolina. She is incredibly self-confident, fearlessly friendly. There is not an adult, child or dog that she does not want to stop, smell and make friends with. We live in a block in Boerum Hill, Brooklyn, memorialized by author Jonathan Lethem in *A Fortress of Solitude*. It is a neighborhood full of writers.

I was walking my new dog one afternoon and ran into one of my poet neighbors. Lately, she had had a hard time recognizing me every time we encountered each other. But today she stopped me and excitedly said, *I suddenly know why it's been so hard to recognize you lately! It's not because you have gained or lost weight, or changed your hairstyle. Your physicality is totally different because of your new*

dog. Your new dog makes you walk differently! And I went home reflecting on how my current dog was giving me a new body. My old dog made me walk like him, very slowly, stopping constantly. My body hunched during our outings, performing a nonverbal solicitous concern over his short-legged wellbeing. I also kept my distance from everyone to avoid his growling. My tall, thin, light-on-her-feet new dog makes me stand up straight, trot, sometimes run and confidently approach everyone up close. The body is so contagious.

Phallus & Mouth

After my father had his prostrate removed due to cancer, he mentioned in passing that he lost his virility. It was a shocking confession both in content and in handling by a man with whom I had never shared any intimacy. I attributed it to uncontrollable grief over his emasculated body. Weeks later, while sitting together in the garden one evening, he suddenly got up and announced that he had a gift for me. I was twice shocked now, because my father never gave me anything, much less gifts. He disappeared and returned from his toolshed with what looked like a large, dull-bronze phallus. He said, *I saw it and thought of you*, and casually handed me the heavy object as if this was an everyday symbolic occurrence: caring father passes the baton to beloved son. I was instantly struck by our Greek play. It was one of the clearest Freudian moments of my life: the limp patriarch handing down the scepter of his virility to the elder son: to the son who bore his name, to the artist son, the gay son, the weak son he had driven away. It was a moment not borne out of love, but a dream-like episode produced by a sheer survival of the species instinct. Someone had to continue the family line, willingly or unwillingly. Dad went on to describe the object as an antique fireman's hose head. The object currently stands erect, carefully bound in red *sadhu* cloth (like a Hindu foreskin), next to a feminine young Buddha statue in my home.

After my father died, as his many personal possessions were being inventoried and considered for distribution among family and friends, his dentures surfaced. In fact, quite a lot of dentures surfaced, enough for several men. They were slightly gruesome;

their life-like quality made them seem as if they were actually the whole inside of mouths, with full sets of upper and lower yellowish teeth plus pale pink gums. Nobody wanted them but me. The boy who had been verbally abused throughout childhood and early adolescence by a strong adult mouth suddenly held it in his hands, disembodied by death. It was not so much a moment of revenge, but a moment that revealed the fragility of the aging body and the brevity of even the longest of tortures. No matter the seemingly endless hell of a period, everything passes and becomes a distant memory, washing through the survivor's body.

Fathering Body

Long ago, my young father loved driving cars. He always seemed to have a second-hand Volvo whose heavy steel frame made passengers feel like they were in the bowels of a metallic whale. Dad would take my mother, brother and I on long road trips to explore the countryside by day. By night, he would drive around the outskirts of the city in a cinematic way, like a man exploring the then-newly built expressways as metaphors for his own restlessness, for his need to experience progress, success—modernity. I remember my body loving the back seat. The space felt huge and safe, like a cushioned dark den. Nobody addressed me. The adults sitting up front spoke to each other and assumed that the children in the backseat were entertained by the views or falling asleep to the rhythm of the machine. Thus, I could be quiet for hours, simply watching out the window, my body very close to the door, molding itself to it, holding tight to the handle as the car sped on (something I still do), my face pressed against the cold window, the world passing me by. Landscapes changed constantly, the night views being the most haunting, with colored starry lights. I looked on intensely even as I also imagined possible distant futures. It was during those body-passive rides that I actively dream-walked toward my future.

Years later, I remember clearly seeing my body in the mirror during a Bikram yoga class. I saw the exact place during my development when I was equipped with just enough idealism, dreams and courage to face life. I saw the moment when I set out to face the

world. I was twenty-three years old; I had just completed two undergraduate degrees, in humanities and philosophy, and was about to enter a monastery. I saw myself so young, innocent and hungry for life that I began to laugh with joy. I began to jump inside of me and had to hold my body from moving beyond control. I felt physically capable of anything. My body had no limitations; it was pure potential. This was not about physical strength, but about feeling able to do everything required of me by life.

Many years later, when my old father died on November 25, 2011, I felt exhausted by the psychic stages and social protocols of human death and had a dream in which I saw my body sitting in the back of his car during a night ride, my face again pressing against the window, looking at the artificially colored, polluted smoky sky around a petrochemical plant. It was one of the most memorable landscapes we ever drove through because of its fires and stench, a hellish vision of ecological war. I saw my little body crouching against the door like a fragile bird in an upholstered nest, and I suddenly wanted to weep in my sleep. The future, which had already happened, suddenly became undone, like a tidal wave changing course, drenching me from all sides. Past and future crashed into each other on my body. I was now the fatherless father of my orphaned body. I was father and I was child.

Bodies Assigned *December 2011*

Movement and stasis give us bodies; the positive and the negative give us bodies. Every experience gives us a body. Every moment glues or shreds, builds or tears, heals or wounds our body. Our physical body is always in flux, shedding flecks of skin and hair, eroding but also seeking to re-birth itself. A predictable performance (with subtle variations), a different performance, a new or renewed performance, our very last performance (always unimaginable to the living) is being choreographed all along. It is impossible for a body to perform the same everywhere every time. Even if we reperform a gesture, the body of today is not the body of yesterday and will not be the body of tomorrow.

Bodies give us bodies. I think of all the bodies I have met, and the projections they beamed at me: the assumptions, expectations, demands, prejudices and fantasies they dressed me with. Every time we met, dialogued, argued, fought, made peace, flirted, made love and parted, my body was built, block by block, or broken piece by piece. Although I am more in control of my body than ever before, the many former bodies that relatives, peers, colleagues, acquaintances, neighbors, friends and lovers long gone assigned to me continue making surprise appearances here and there, visibly and invisibly. Maybe it is both the temporary visits or even mere memories of those old bodies that make me appreciate the body that I have fought for, my *body of now*.

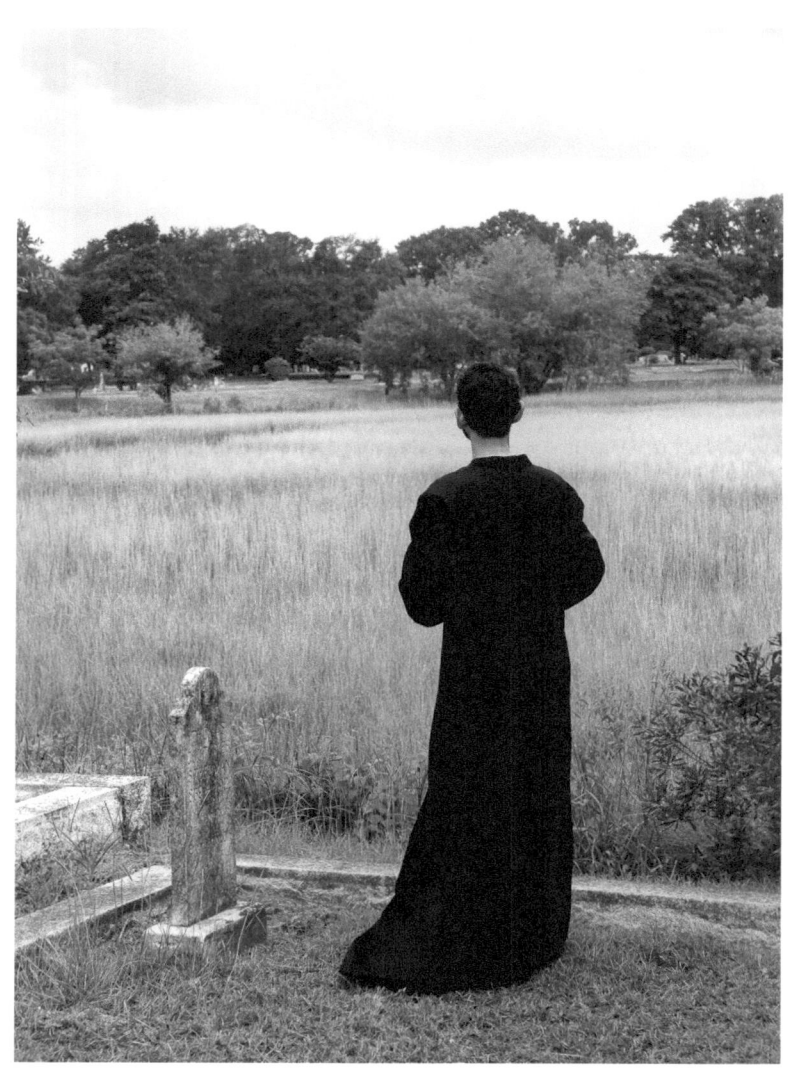

Field, digital sepia image from *Walk #1*, Charleston, 2006

There is a difference between dissecting the psyche and opening up to the psyche. In the first case, it hides from us, playing tricks. In the second case, it reveals itself, performing our visions.

Chapter Two *Psychic Bodies*

The Monastic Body

The body of the monk is the embodiment of infinite hope. Yet I wish that Western Christianity had developed a wandering monasticism, an urban monasticism of monks in the world like Enku, the seventeenth-century Buddhist monk and sculptor who walked throughout Japan and carved 120,000 statues of the Buddha while publicly performing enlightenment. Christian male monasticism, however, went the way best exemplified by Mount Athos, through hermetic cloisters and the exclusion of the feminine.

My young body wore a monastic habit. During the early 1980s, I spent four years as a Cistercian of the Strict Observance, commonly known as Trappists, living under the sixth- century Rule of Saint Benedict. I lived as a cloistered contemplative monk under vows of poverty and silence. Whatever covers the human body when it exits the world (secular space) and enters a monastery (eschatological space in-between heaven and earth) is discarded and replaced by a white habit and a shaved head. The habit is a sign of the monk's metaphorical death to the world (it is a shroud), of the taming of his body (both ignored and mortified) and of his desire to be reborn like an empty vessel so he can be filled by divinity.

Everyone and everything aims against the new monk's mind and body during the first two years of *postulancy*. This first stage of monastic training seeks to empty the mind and subdue the body, the two "possessions" that the postulant was not able to leave behind. For this reason, the postulant sleeps in a small cold cell on a wooden plank or a very thin mattress, rises every day at 3:15 a.m.

(the point of deepest sleep) to pray in the middle of the night, then meditates and attends mass. The postulant works in the monastery's farm or other monastic industry, regardless of academic training, in perfect silence, external and internal. There is nothing harder than submerging into and sustaining this silence of body and mind, soundlessly moving through space as if floating above ground while also subsumed in complete internal silence.

The monastery is effectively killing the postulant and the postulant is dying. All matters of faith aside, if the postulant surrenders to this grueling, daily ancient training based on the renunciation of all material possessions through voluntary poverty, bodily discomfort and celibacy, sleep deprivation, manual labor, a frugal diet and unconditional obedience, the ego dies a dramatic death, the most important of its many subsequent deaths because this first annihilation opens the doors to all the others. Indeed, the ego has to die thousands of smaller deaths as monastic purification continues throughout a lifetime. Large and small daily trials continuously exhaust and frequently humiliate the postulant's former personal and professional identity through small and large failures until he is physically and psychologically vulnerable—until he is raw. At that pivotal point, the ego revolts, refusing to die, seeking to survive by unexpectedly harvesting the remaining images and sounds buried deep within the mind of the postulant, playing his entire inventory of sensations. Experiences unknown to have been recorded during early childhood or long forgotten now surface. It is like watching a chaotic multichannel video projection in a windowless cubicle. The postulant experiences night-and-day visions, hears voices and is transported to where he needs to go to ask forgiveness and/or forgive.

The postulant's mind, the vessel of the ego, is emptied not just of his first-hand experiences, but of all the vicarious and virtual living he did through friends and media. It releases all the music, shows, films, and videos that he ever experienced. It is like the near-death experience of seeing one's whole life flash by, but it lasts longer than an instant; it lasts for days, weeks and months, depending on the ego's strength, or, as described in monastic terms, depending

on one's resistance or willingness to die to the old self. Whether it happens at the end of the postulancy, or during the *novitiate* (the second stage of monastic training) as the ideal precondition to making *first vows* (also known as simple or temporary vows, the third stage of monastic training), monastic formation is meant to bring the new monk to a moment of *psychic death*. The new monk dies to the self even as he continues to live. But the new monk now lives selflessly and humbly, without ego, even though he retains the qualities of character (distinctive mental and moral strength) and dignity (confidence and serious self-respect). And this is important to note, because being egoless does not mean being characterless; quite the contrary. In fact, the constant nurturing of a dignified character is a requirement for the constant loss of ego. There is no one more fearless and strong than one who is egoless.

Two Trees

I am struck by how the body is sadly treated as an adversary throughout the Christian purification process. I miss the musty nakedness of the Buddha covered with ants and twigs while seated under a Bodhi tree. The nakedness of Jesus is about the torture of a youthful body, while the nakedness of the Buddha is about his reintegration into nature. That is how the Buddha's enlightenment came about. It was the result of sitting butt-naked on bare damp soil under a big old tree, with creatures crawling and buzzing over his skin, with debris falling from the tree onto his body, with animals visualizing him as another animal. That degree of sitedness was the door to enlightenment: the interconnectedness and interdependence of all accessed by his body.

I imagine the Buddha as brown and moist as the living tree that gave him shade. By contrast, there was no integration between Jesus and the lifeless tree cut down to be his cross. Moreover, there was no reintegration into nature even though his dead body was placed inside a sepulcher. A sepulcher is like a compost pile, recycling the body back into nature. But the Christian article of faith is that Jesus was resurrected, and the resurrected body is based on jumping nature.

Christianity is like whiteness: it would be much healthier if it was just a color among colors, but the myth of the resurrection insists on the religion's superiority. I wish that the Christian narrative accepted Jesus's death, so that what was resurrected and sustained among his disciples was his teaching rather than his body. Jesus's teachings are remarkable but his resurrected body is mythology. The promise of surviving death, of course, was and remains the key to the successful spread of Christianity worldwide. But I prefer the body of death to the prescientific myth of a resurrected body that will inevitably perform an increasingly minor role in history because it is unnecessary. I live by Christian and Buddhist ethics, not because of promises of eternal material life, but because they are valuable in themselves.

Prophetic Bodies: A Glimpse

The true prophet's body, the body of austere stewardship of our remaining resources, is extremely annoying to societies that worship a false body, a body disconnected from nature. In America, the cult of the false body produces extremes, such as obese and hard bodies: the first constructed through a perversion of abundance and its right to waste; the second through leisure informed by narcissism. Even American human rights are understood in terms of accessing limitless credit so as to achieve the false body. Working-class and poor American communities tragically misunderstand prophetic agency in terms of assisting them to become endlessly consuming bodies, rather than ecologically sustainable bodies. Thus, those who have full rights shop the most. Within such an environment, wealth is a sign of God's favor. No wonder American false prophets dress like bankers. In the near future, American performance will need to become a collective healing practice, ranging from generating a healthy discomfort to confronting pain, loss, anger and sadness, so as to evolve as a people.

Mystical Bodies

The story of God is a story of abandonment. It is well documented in the literature of mystics that when divinity touches you, it

immediately runs away. New monks speak of the emotionally devastating experience of entering a monastery through the front gate while God exited through the back door, suddenly feeling nothing after entering. Or perhaps it is a question of contrasts, because after experiencing a vision, a mystical moment, the rest of life feels like a very slow, post-climactic, blind crawl through a long and narrow hallway, where you hope to reencounter the thing once experienced, which may not be re-experienced until the very moment of death—although mystics also speak of dying feeling totally orphaned by divinity.

Most mystical treatises speak of visions as food for the weak. As Christopher Isherwood was humorously told by his matter-of-fact guru, Swami Prabhavananda, even dogs see spooks. The strong, those truly endowed with unconditional faith, spend a lifetime without such cotton candy. The mystical body is as strong as it is transparent, like drinking water. We all know the weight and the strength of water. Even if the body experiences visions for a remarkable period of time, those visions will end and become increasingly distant memories, so distant that they will seem to matter little, like barely remembered childhood nursery rhymes whose messages, nevertheless, once launched a practice in the world.

Body of Yoga

I began to practice Bikram yoga in earnest during fall 2007. I had undergone a traumatic separation from a lover and was experiencing a monkey mind, obsessing about failure and loss, and a paralyzed body that only wanted to vegetate in bed, to hide under the covers. Inspired by a friend who attended a weekly restorative yoga session near her home in Park Slope, I began to look for the right yoga practice for me throughout the small studios scattered across downtown Brooklyn. In the end, I settled for a Bikram yoga studio on Montague Street in Brooklyn Heights. My photographer friend Jenny Wilson also took classes there and would eventually become one of their teachers.

I practiced Bikram almost daily for a season. I realize now that it

was the rigorous reawakening that my body desperately needed. I was trying to reclaim my body, which had somehow been lost during my recent turmoil. I believe now that my body sought some form of irreversible healing through painfully stretched tendons and purgative sweaty pores that would embed itself like an unforgettable, trained muscle memory.

I loved how Bikram yoga confronted its practitioners with themselves by having them face floor-to-ceiling mirrors. One performed one's bodily practice facing one's baggage directly. The practitioner was not distracted by the teacher or the group. The practitioner had to confront him- or herself. In addition, a regimented sequence of quick poses, twice-repeated during sessions, assured that no one was comparing their delivery to their neighbors.

I remember the day when, focusing on the space between my eyes, my third eye suddenly opened. It was like the opening of an ancient cave, enormous, filled with bright light. My third eye took over all my other features. My head became a huge eye. I was all eye. Through it, I saw myself anew, untouched, unscathed. I was surrounded by a full body aura of gradating lights. But just as it had spontaneously opened, my eye closed, completely beyond my control, as if it had a life of its own.

Months later, I fainted hard during a Bikram session. My head hit the floor like a rock. The next thing I new, a teacher was telling me to sit up straight and not move. But even as I did so, I could not open my eyes. I was stuck in a bottomless darkness. My mind was convinced that I would never return from it. I was conscious but unavailable to the world. I thought that this is what death must be, like falling into a titanic well and losing all sense of individuality, all memory. But the darkness began to dissipate, and I started to see light. I could not move yet, but I could see the room. Finally, after feeling that I would never move again (each stage of return being like a closed environment, as if there was no other experience but that state), I got up and walked to the men's changing room. Although I knew that fainting is not uncommon in Bikram, my body was telling me that it was done, that it was time to move on.

And although I have returned sporadically, I was through with it as a daily practice.

Performing Enlightenment in the Marketplace *July 14, 2007*

Friends took me to witness the New York appearance of Mata Amritanandamayi Devi (Mother of Immortal Bliss), born Sudhamani Idamannel, better known as Amma (Mother), the Indian guru, mystic and philanthropist, popularized as "the hugging saint." Thousands attended her morning session. We received a number and waited our turn, first sitting, later strolling around the many decorated tables selling images, jewelry, fabrics and clothing, promoting and supporting her charities. We were assured that a portion of all sales went to the poor. We ended up shopping, much to our embarrassment, and enjoyed a tasty vegetarian lunch. Before the encounter with Amma, there was a guided group meditation by a man with a microphone. At first, the man's loud voice bothered me, but I eventually settled into it, marveling at how the crowd willingly surrendered their bodies to his direction, becoming very still.

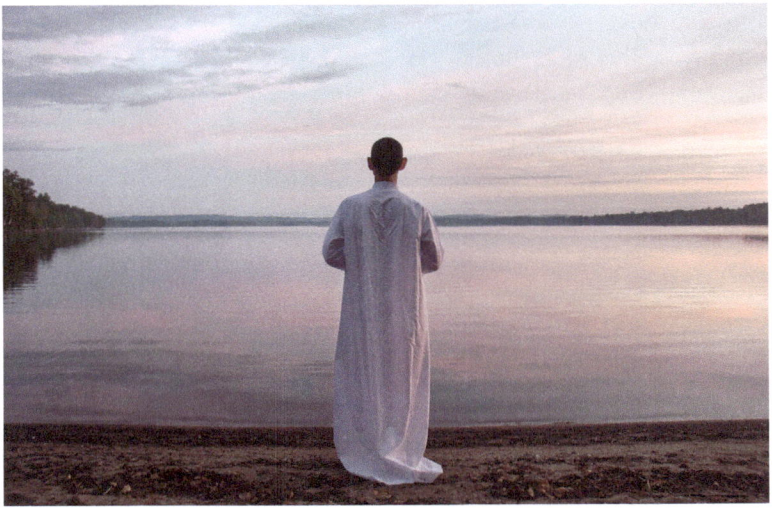

Lamb 1 (left panel, diptych), digital image from *Baptism*, Lake Wesserunsett, 2010

Our physical approach to Amma was fascinating. She was surrounded by the bodies of her most devoted attendants. These men's and women's bodies actually formed what amounted to a room around her, a psychic architecture of four almost-tangible walls and a portal. Their bodies were very performative: they were grounded, almost immobile from the waist down, while extremely active from the waist up, like trees blowing in the wind. Remarkably, they were not silent, constantly exchanging messages with each other and issuing commands in the various native languages of the approaching faithful. Their care, management and arbitration allowed Amma's eyes to remain focused strictly ahead and her body to perform unconcerned. I found them a bit overprotective, but I understood their necessary ministry filtering the masses.

When our number was called, we were instructed to take off our shoes and approach the beginning of the long line. The first stage consisted in sitting on two parallel rows of chairs facing forward, imitating a child's imaginary train game. We moved forward in line from chair to chair. The next stage consisted in kneeling on the floor, where we were handed white tissues to wipe our face clean of all makeup and asked to continue moving forward on our knees. Enthroned Amma was so completely enveloped by her efficient attendants that even though I waited at the foot of her stage, a few feet away from her, I barely saw her. In fact, I did not see the person in front of me being embraced. Attendants' bodies parted, absorbed his body, and closed again like thick curtains. The person simply disappeared before me.

When my turn came, attendants turned to me. I was instructed to cross my arms over my chest. I heard women to the right and left of the guru say *One English* (meaning, a single person who speaks English). I suddenly saw Amma's massive body, and her hands and arms immediately grabbed me powerfully as a giant mother picks up a small startled child, holding me tightly in a hard fleshy grip, her big round head next to mine like a boulder.

After that first rough physical embrace, almost suffocating in

her arms, I felt a second psychic embrace with the briefest pause in-between, as if after settling into her bosom she had suddenly hugged me deeper. It was an embrace within the embrace, and I fell into an abyss. Amma chanted a prayer into my right ear in an unexpectedly rough bass voice that sounded like a metallic instrument of the lowest range, completely quieting my mind. My slate went blank, erased. There was only silent emptiness. And just as I was falling deeper into the bottomless depths of that vast inner place, she suddenly let me go, unlocking her grip, almost pushing me away as her attendants, standing ready to receive me, grabbed me by my shoulders and pulled my body back. It was a perfectly synchronized dance.

Later, I was told that she looked at me (that she looks at everyone in the face after her embrace), but my head was down, my gaze to the floor, deep inside a well. But even as I was psychically detaching from the mother, gifts were being placed in my hands, so that I rose clutching little things without knowing what they were. (They turned out to be chocolates and rose petals.) I was helped to rise, shakily, having to make room for the body next in line, stumbling as if in a trance, weakly walking away, still in silence's grip, not wanting to break the silence, wishing to remain in that great silence for hours, forever. I had to sit down, then kneel down, my body almost crumbling, to recover.

Puritan Bodies *Late August 2007*

Everyone writes about the Puritan body in terms of repression. But I would like to address its chaos, the very opposite of what it is associated with, yet as much a part of it as its containment.

The Puritan body is a vessel for chaos, because Puritanism generates an eruptive response, sooner or later, in secret or in public. Of course, some argue that cultures of carnival are chaotic. I would argue that such cultures manage chaos daily, weekly, monthly— all year long. I would add that carnival is just a metaphor, a performative climax that is not meant to destroy but to remind and thus assure the constant flow of uninhibited play.

Puritan bodies, on the other hand, gestate a destructive and self-destructive chaos. What triggers the eruption of the Puritan body is a combination of repressed needs and self-hate for having such needs. The Puritan body does not seek to be angelic. The Puritan body seeks to be a machine.

I grieve over the Puritan body's chaos. I would like to meet a redesigned Puritan body devoid of the secret desire for cathartic self-expression that must then destroy all who witnessed its chaotic release, plus its guilty self. I would like to meet a white body of desire that does not colonize, that does not lurk, that desires openly and joins a democracy of desire.

Mindful Body Over Time

I once wrote in a monastic journal that I sought sanctity, personal holiness. I am still willing to embarrass myself and write that I seek enlightenment, awakening to a fully conscious life. I once thought that this meant giving up all material possessions and entering a monastery, dying to the world. But if everyone performed that, we would be a *culture of death*. The same goes for the pilgrim gesture, for the *culture of pilgrimage*. It would not do for the entire world population to be nomadic, even as nomadism seems in better balance with nature, as it never exhausts any single landscape. The monastic and the pilgrim experiences must be constantly renegotiated by those of us who seek to be enlightened in the world as sited stewards of public spaces.

Body Walking No-Where

Body walking no-where... Whose is this Body? Why is it Walking? Where is this No-Where? It is the monastic *body of interiority?* Walking is the pilgrim's metaphor for quest. No-where is the psychic space of the no-mind, the intangible environment of the no-self, the shifting sands of selflessness.

The body that walks no-where is a no-body seeking to be every-body because of love. The body walking no-where loves. And

through love, it generates a new body for itself, new bodies for others and new spaces. It radically cuts through old spaces with humble vulnerability, creating true ground.

This body walking no-where deepens, its walk creates depth, walking horizontally and vertically, across and in, until inner space and outer place open up to reveal inner layers, a hidden architecture of dreams and nightmares, desires and fears, hopes and insecurities, blessings and curses. It manifests the psychic architecture of crimes committed and battles won; acknowledged and unacknowledged mythologies, histories, stories, anecdotes, narratives, memories, cries, sobs, laments, wailing.

It is a fierce body because it seeks to become a public body through the public's body, becoming one with humanity. It is a body that seeks communion, integration as its destination. Thus, performance is not a destiny, but a strategy and a path.

Dateless Journal Entry

I die with every new performance project. I experience a kind of death. I willingly die to all I have been until then. The project edits me, pulling and pushing out, cutting and reshaping until there is not much left. All this is always painful and, knowing what I undergo, I start to grieve over the pain-to-come long before it begins. As much as I try to avoid a precious notion of myself, constantly detaching from the mythology, I enter the project grieving over the inevitable loss of parts of me, even as I rejoice at the prospect of being reborn.

I manage a system of checks and balances based on constantly trying to have nothing to hide, protect or guard. Public performance art demands dropping your guard, ultimately seeking to have no guard; so that there is no armor to recuperate and wear again after the performance; so that the body remains in a permanent state of openness before, during and after a performance.

I try to remain empty and walk unburdened as the result of all that

has been edited already, but I always discover more to shed. I never look forward to dying, but I can see through pain and look forward to yet-unimagined transformations at the end of the process. Thus, I select my projects more carefully than ever before. This is not as a style but a way of life. I can only die so many times, so I must die wisely.

Rotting Bodies

Early Buddhist texts admonish young monks not to have sex with animals or corpses. They actually encourage them to look at corpses in various stages of decomposition: to stand or sit at a respectful distance and gaze at rotting human flesh. It was a crude practice but a fascinating revelation of the landscape of the *body of desire* at the time. This brutal admonition went far beyond the notion of loss, the recall of the fleeting aspect of all things, of the aging, illness and death of human bodies. To seek and contemplate the body's breakdown meant to eradicate all desire for the body and the fetishized body part.

War perverts all desire for the body. Nowadays, contemplating the rotting body only enters my imagination when I am confronted with media images of war in the Middle East, in articles about suicide bombers and roadside bombs that explode and leave burnt body parts littered about the landscape; or when I read of US soldiers carrying off small, enemy body parts as good-luck amulets.

Spirit Body *December 6, 2011*

When my father died following Thanksgiving, after suffering terribly for several days, I saw an image of his soul running away like a happy child, skipping and laughing all the way. He was like a little boy who had been punished, shut in his room, suddenly freed. My father had always been a very strong man, so to witness himself as weak, shaky and sickly was unacceptable; it made him very depressed. In the end, unable to tolerate pain medication because of irreversible liver damage, enduring phlebitis and sores, he suffered horribly. So his death was an incredibly joyous release for his soul. His soul ran away so fast that it disappeared for hours, for a few

days. My mother and I commented that he was totally gone. There was no sense of his lingering around the house.

After that first image, however, he finally came back, but this time as a man in his early thirties, sweating, in tears, with a mouthful of saliva, blood and vomit. I mostly saw his head as he was trying to tell me something. I responded by telling him that it was alright, that all was forgiven, that he was released from the past. I then saw his mouth explode. All its contents vomited out, and once again he disappeared. I had a sense that he was now being purged.

The third time I saw him, he reappeared as that same man in his early thirties, but now clean and handsome, standing upright, silently smiling peacefully. And that is how he remains around me, coming and going, appearing here and there, sometimes sitting in my living room, sometimes standing before my bed. I see him not as a ghost, but as a quiet, unassuming apparition. I do not know how long his spirit body will be around before it goes on to rebirth, but it is a pleasant, nice visitor. I speak with him, joking, wishing it had been this good when he was mortal.

I will not expand on the spirit body, but it seems to be the hidden body of my every performance.

Walker

Walking down a street can be a transformative experience if you clear your mind of all thoughts and images, and achieve a silent no-mind sight. Although you can try it anywhere, anytime, I love this practice best when walking down an empty tree-lined street. I become increasingly quiet, dispel all thought, close my eyes as I take a deep breath, open them as I exhale, let myself gaze randomly, silent, finally free of ideas and images. I repeat this as much as I need to without growing frustrated. The process is like a careful dusting, like patiently waving away assertive flies and sluggish moths. It may take you a few times because, commonly, just when you finally achieve it and your gaze contemplates some detail you have never noticed before, wonder is invoked, and thought resurfaces.

Engage in this practice repeatedly until you achieve it. At first, the silent no-mind sight is brief. The mind abhors a vacuum and wants to analyze what the gaze discovers. In fact, the body too may even feel jumpy. Over time, with patient practice, the sight periods begin to last longer, and you can walk distances in this peaceful all-seeing state. You will notice many wonderful things you never noticed before, but the challenge is to remain without thought for as long as possible, letting things and places speak to you while holding back your thoughts. It is like knowing there are many racehorses at a distant gate, ready to gallop, but not releasing them yet.

If you have a dialogue with your mind and it knows that it will enjoy freedom to reflect later on, it will allow itself to be temporarily contained and even suspended. It is like intellectual fasting. If the body knows it will be fed all the nutrients it needs at the end of a period, it will wait patiently, it will fast, because it knows that you are not starving it, that you are not hurting, torturing, killing it. The same with the mind. It will cooperate with your desire for silence, for the suspension of thought, if it knows that thought and speech will be allowed later. Dialogue with the body and the mind are key to the stillness of both.

Sometimes, as I enter this state, I stand very still, as if my body were waiting patiently for my mind to stop working; my body's senses achieve calm first. Indeed, once my mind is empty, my body takes over, walking on without need for thought. My body knows what to do. Of course, urban architecture is all about proscribing human traffic, about lines that nonverbally tell bodies where to go, or not. So this exercise is easier in the city than in the country.

During this *state of sight*, I often feel as if my eyes have grown disproportionately. I am all eye, absorbing more, enjoying both microscopic and panoramic views, like a dog, as if my eyes had shifted back and I was able to see before and behind me a much wider range of landscape. My breathing becomes slower but deeper. I am more aware of this heavier breathing because it begins to determine the speed of my steps. I breathe, I step. I breathe with every step; I step with every breath. I look up, ahead, around, and

everything has changed. Things suddenly have a charge; some vibrate. Even the stones, the gravel, the bricks, the cement and the asphalt evidence a remarkable integral presence. At first you feel their quiet humble thisness at very low levels, but over time it too gets intense and even loud.

The presence of the city's trees is my greatest discovery in this heightened state of awareness. Trees are the most alive beings I encounter. Some are in pain, mutilated by cars and trucks, or vandalized by people. (Strangely enough, I never hear them complain about dogs.) They are young and old, male and female. I dare touching those that seem to allow it, as if coming up to a wild elephant in a forest clearing. (I dare not touch the angry ones.) My hand rests on them respectfully, and they stir, aroused. I feel the trees going down deep into the soil through sand, cobblestones, rocks and red clay. Some are at peace, and some are on fire. The angry ones would uproot themselves and kill some humans if they could. But all observe a vocation of stillness.

The trees are so intense that sometimes I refuse the sight. I purposefully avoid it because it is too painful, too much to bear. So I walk around knowing that it is there, behind a veil, catching a glimpse once in a while, emotionally unable to look all the time. We have done so much damage that to enter this realm is first and foremost about confronting crimes. I remember being in a monastery and living in this state of heightened awareness all the time. I experienced the sight daily. I remember one afternoon when I looked down at the grass beyond the abbey's enclosure and I could see distinctly every blade of grass in its uniqueness. I could see the singularity of the millions of blades. I experienced the individuality of each through their multiple layers. And I was but a blade of grass too.

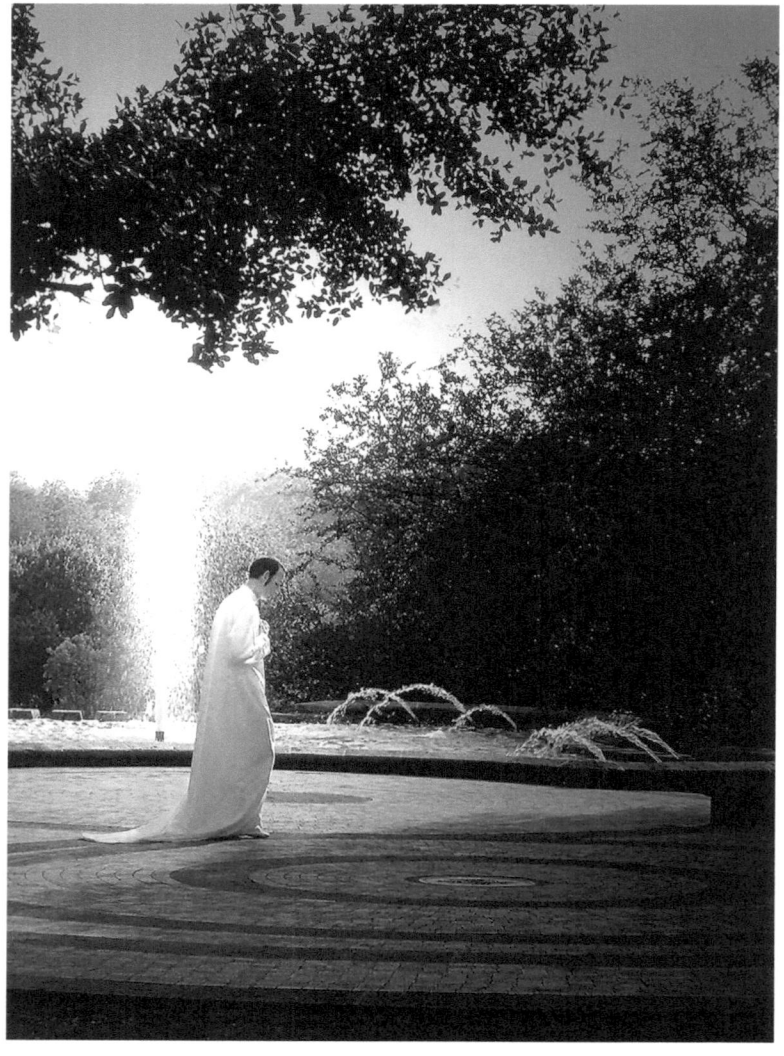

Mourning Circle performance, digital image by Michael Jay Smith, San Antonio, 2006

When a performer is young, what is gesturally easy is often ignored in favor of what is hard. Ironically, it takes a lifetime to discover that what is gesturally easy is often what we are best at.

Chapter Three *Eating Performance*

Performing Multiple Experiences

Performance art can be the signage of human consciousness, which evolves through increasing awareness triggered and fed by multiple experiences.

I believe in recognizing and protecting the authenticity of the full range of experiences undergone and sometimes staged by an interdisciplinary performer: from undocumented private experiences, to documented private experiences whose materials will eventually have an audience, to private experiences eventually reperformed for audiences, to always-public experiences performed and reperformed for audiences.

We experience something meaningful privately, and we meditate on that important solitary experience. Eventually, we try to remember and even hold on to what is increasingly becoming a distant memory, a vanishing glimpse, employing images, objects, words and gestures so as not to forget. I believe that the stages of this long, complex process can be imitated in performance art.

I can perform alone, for myself and for my site, or with a special silent guest witness, as in the practice of *Authentic Movement*, but without producing any private or public documentation or art. I can decide to perform in this solitary undocumented space out of respect for the fact that the site is sacred to me or others. Perhaps I am also seeking something pure and intangible; seeking to avoid becoming self-conscious during my gestures. I may not even have the intention of eventually producing art; I am simply seeking an experience.

Nevertheless, once I have protected the dignity of the site and the integrity of my first set of gestures, I believe that I am then free to revisit those sited gestures through art, because I have had an authentic first experience. I am then free to edit my memory, to embody memory, to materialize memory. I am ethically free to reperform the most important moments of that first experience, to seek to generate art for an audience, in terms of performative photography, performative video or live performance at that site (if appropriate) or elsewhere (if not totally decontextualized). My art products will result from a different but authentic second experience created for audiences as an act of memory, skill and generosity.

This conviction also proceeds from my belief in the need for and the power of images. I was initially trained as an image-maker, so I combine notions of painting with performance art into various kinds of performative imaging, seeking to assure the performer of multiple options while being respectful of site and experience, and being generous with audiences. Because to pretend otherwise, to only understand performance art as what is produced during a one-time experience, without an opportunity for reperformance, is to engage in a rigid notion that disregards the experience of loss and the subtleties of recovery within the human condition.

Of course, this is mostly an argument about the making of performative images and performative video. Many performers will both document themselves and make art during a one-time experience. But that is not their only option. The boundary between performance art and theater, between performing and acting, does not lie in repetition. It lies in the creation of authentic experiences rather than the mimicry of experiences. It is said that a great actor memorizes and then disappears into a role. I would say that in performance art there is no one to disappear, and no role. A great performance artist embodies isness.

Denudation

My body strips itself (strips itself of the mind) before walking into a space. This first act of *psychic denudation* gives my body the moral

authority to walk into a space and immediately begin to strip it. My external gesture mirrors my internal gesture, and that is why I trust it, because I first apply it to itself, and thus, it is humble even if it is demanding of others.

My body instinctively gets rid of all the carpeting, furniture, curtains, lighting, signage and everything else that came to fill the space after it was first built. It will get rid of stationary partitions and movable walls if it can. My body seeks to strip it down to its original skin (if not to its bones), as it hopes to strip itself bare in front of an audience. It seeks not so much the architectural purity of a space as its institutional truth. It seeks to reveal the ideology that built a space; it seeks to make the space do what it once did to its first visitors.

My body always gravitates toward historical emblematic architecture for this very reason. It finds that such architecture usually embodies the dreams of a people, or, at least, the dreams of whoever dominates a people at a given time. My body strips surfaces. It performs this architectural surgery with silent urgency.

Reporters have often interviewed me while I was dusting, sweeping or mopping. I remember spending an entire day during summer 2008 with my performance group in Tel Aviv methodically removing broken glass and soot from the roof of the building where we were going to perform barefoot for nine hours. We performed the cleaning barefoot, slowly feeling for shards with our bare feet. Only after a space has been emptied of all superfluous material, whether harmless or dangerous, does the body feel safe to move freely.

Driving, Waiting, Inhabiting

When one visits the archival website of the former Goat Island performance group, the first thing one reads is that they discovered performance by making it. That is my own experience.

People speak of the mind driving them, of the heart's passions forcing them, of the spirit lifting them. But it is the body that

takes care of the mind. We may think otherwise, as we live in our heads and constantly research, dream up plans and issue commands about changing course. But it is the body that rules our walk. All it takes is illness, and the mind is suddenly trapped in a body, feeling helpless. Yet, when it comes to the body, people only think of heroic endurance leading to achievement, and sex.

I find that the body possesses its own wisdom, not just in terms of a self-healing but in terms of purpose and direction. I often say that my body made me perform. My body needed it, not my mind. In fact, my mind was embarrassed (if not terrified); my heart was afraid; my spirit was unsure. But my body walked onstage firmly, clearly knowing where it was taking "me," confidently transporting itself. My body did not hesitate; it moved briskly. My body was hungry for performance; it was eating performance.

I have spent a lifetime looking at all manner of performances, watching closely, and listening to performers' interviews and conversations. I have always been amazed at the amount of waiting involved: waiting for project funders, project staging institutions and their curators to respond to performance proposals; waiting for collaborators, gatekeepers, stakeholders and technicians throughout the production process; waiting to perform and waiting for the performance to take hold of both performer and viewer; and waiting for short- and long-term reactions to what was performed.

My work inhabits a crossroads where contemporary dance, visual art, ethnography, psychology and literature intersect. I am aware of the challenge this poses to art critics who are not interdisciplinary, but I invite and encourage those professionals to rise to the challenge. I am generally at peace with paying the price for inhabiting this intense intersection. But even when consistently hopeful, it can be exhausting, and my body will sleep for unusually long stretches, like the naps of Orlando in Virginia Woolf's novel of the same name. My body desires for the age to pass and then to awaken in the next time period of understanding.

Timing

Dear Lin, *December 5, 2006*

Thank you for the reading list. My semester comes to a close next week and I am free through early January. I do not travel to Hawaii to begin work on that walking performance until the 10th, so I hope to immerse myself in a sea of research.

I have always considered myself to be a maker who works from a very intimate and intuitive place. Much of it was initially fed by a combination of feminist and queer theories, and during the past few years, by the Buddhist notion of a seamless practice. I have always been a Buddhist, but I did not always have a word for it. Nevertheless, even calling myself a Zen Buddhist can be restrictive. But humble Buddhist language serves us well. I need a language, and I much prefer it to art-theory language.

I confess that I no longer look that much at the work of other artists. I did that as a student and during my early professional life, of course, mostly trying to find my art-genealogical tree, my tribe of peers. My early installations of male body parts were compared to Robert Gober's work in a 1998 *New York Times* review by Ken Johnson. The work was also associated with Ann Hamilton, Louise Bourgeois and Kiki Smith (a strong women's pantheon).

However, I went on to create mostly from a place of intuition informed by world events (politics, the economy, the environment) rather than by the art world. Of course, this has made me marginal to my own community, as I have often chosen a different direction from the pack. This has also meant that sometimes I have been ahead of the pack: that what I was performing alone one summer turned out to be what everyone else would be pursuing the next summer. It is interesting to witness.

I think that I learn best when able to take my time reading a passage, as the monk in me can meditate for days on just a few phrases. I also learn tons from observing and listening to people,

particularly accomplished actors. I wish that I could spend time in a warm dance studio with just a handful of empathic individuals, sensitively exploring movement followed by evaluative conversation. I think that I am going to try to create this for myself over the holidays, even if it takes conjuring childlike imaginary friends in an imaginary place.

Warmly,
Ernesto

Notes to a Young Performer *Summer 2006*

We never really know what will remain if we let go of our baggage, and if what remains will be enough. All we know is that our bodies will walk more lightly, as they must in order to move forward. Of course, whatever the body sheds remains with us. It doesn't really vanish completely, but our body's relationship with it is different. It no longer defines and narrows us. It is now at our service, like a more neutral objective fragment of information.

If you choose to shed the smaller label of painter for the bigger label of artist, letting go of painting might actually affirm the painter in you because you are assuming the right perspective. *What matters is not the body of the medium, but the body of the artist.* When you let go of preconceived notions about making art, what remains is a freer, clearer you; the ground from which to make better curatorial decisions. Letting go is about discovering and rediscovering aspects of your practice that you repressed, forgot or dismissed as not art, yet nevertheless kept doing outside your own radar of propriety.

But if you still do not trust what I am saying, think of it as scanning your body to train different muscles. Why should you only be driven by what you think your hands can do? What about your feet? Why not give a chance to every limb in your body to see what it is capable of? This is not about developing a multimedia portfolio, about yet another grand plan directed by the mind, but about finding out what your body truly excels at. You will not find this if you fearfully lock yourself into a single medium at an early

stage of your training. This is an invitation for you to become the artist you want to be. Performance is terrifying to most people. It certainly was to me at first. Even now, I still get nervous before performing. But fear should not curate our practice; fear should not be the curator of our work.

Economy of Gestures December 2006

I just watched *Nefer*, Pina Bausch's new piece presented at the Next Wave Festival of the Brooklyn Academy of Music. I was intrigued by her controversial sampling from other cultures, which I do not regard as cultural DJ-ing but either as an innocent gesture (staged cultural tourism), or a lingering, unfortunate, European, colonial, unselfconscious entitlement, even as her signature dancers, costumes, gestures and themes subsist and thread themselves through everything. There is so much walking in her work. Her dancers walk half the piece. In addition, there is a collection of what I would call art performances within the dance performance. The art performances are so good that it is a shame that their potential as single pieces is lost within the larger piece.

A woman draws a circle of chalk around herself but quickly dismisses the gesture. Performers knead pillows, like dough, over a table. I can envision many of these gestures as isolated slow performances I could watch for hours. Of course, Bausch is practically a demigoddess to me, so I assume that she knows this. But most young performers generate gestures like machine guns, never stopping long enough to inventory and discern them. They just keep going, sometimes missing the very best gestures that their bodies are organically capable of making. I am always slowing performers down.

Dialogue: Two Men January 2007

First Man: Two men gaze at each other across a divide. At one point they walk toward each other. They seem about to meet, but they merely exchange glances or places.

Second Man: Maybe they exchange something; they give each other something?

First Man: Maybe there are more; there are three or four men on a field, on a Midwestern prairie? I have been trying to return to Kansas since I left. I fell in love with that landscape. I want to be buried there. Maybe it's about Willa Cather's bachelor farmers?

Second Man: Maybe something is made? Maybe only two of the men touch, but the rest don't.

First Man: I want them to sustain a tension. Their old clothing can sag, a bit oversized, tightly belted at the waist so their pants don't fall down, as if they were poor farmers wearing hand-me-downs in shades of faded browns.

Second Man: Maybe they all come together to meet at a crossroads and then all walk away? They come from every direction, meet briefly and disband in every direction; all that a video camera witnesses is a brief meeting. (Or is there an audience?)

First Man: Maybe they can never have each other? Perhaps they walk away in pairs but without touching, because even though they dared to come forth and found others (and they were found), they cannot have each other. Or maybe they all come together but do not become pairs? I am always matching and marrying people; I do not want anyone to be alone... But what if they simply extend theirs arms and touch each other, creating a little circle with the tips of their index fingers? And what if after they did this, they turned around and walked to the audience breaking the fiction with the townspeople watching and touched them too?

Second Man: What would happen next?

First Man: I don't know!

Second Man: Nice.

Process Stages

Dear Mary Jane, *February 6, 2007*

In response to your question, my first walk addressing the subject of war took place at Magnolia Cemetery outside Charleston, South Carolina. First, I have to explore a place alone, developing an intimate relationship with it (material and immaterial; embodied and disembodied), away from the camera, as an undocumented hidden process that is not self-conscious. I need to be like an animal on that (sacred) soil, water and air. Second, I seek to transform and elaborate my initial private solitary gesture into a gesture for the camera that will have a public life. Third, I begin to let the public in, but only after that profound complex relationship is strongly established. So there are three stages to my walking performances.

Gaze public intervention (MECA MFA students pictured), digital image, Portland, 2007

My initial preparatory walks revisit the past (the dead), but my final public performances are about the future (the living). That is how this performance practice seems to be evolving, one walk at a time. I am simply flowing within the process, trusting it. In addition, I want to make my practice increasingly transparent, to be accountable to all gatekeepers and stakeholders, to all conscious and accidental witnesses.

Warmly,
Ernesto

Paths

Ernesto, *March 2007*

My eyes are more open than ever. I am more receptive to my surroundings outside the solitude of my studio. A walk from the subway is a constant journey of discovery. Rather than taking the same walk each day, I arrive at the studio, drop off my bags, set out for a cup of coffee, and then walk an unknown new path for thirty minutes or so, just exploring the neighborhood. By not taking the same path each day, my ensuing studio moments have become far superior. I reenter the studio calmly, inspired if not by finding something new, by the gift of the day itself. My blind walking is like the unanticipated discovery of what will emerge from within me at any unsuspected moment.

Chris

Selected Correspondence

In April 2007, Emory University held a public conversation on love and the creative process between insight meditation teacher and writer Sharon Salzberg and artist Janine Antoni. What follows is a selection of edited excerpts from our e-mail correspondence, comparing our creative processes as she prepared for her lecture.

Ernesto,
It is challenging but exciting to try to speak about love. I am working to figure out how to address the art community and the spiritual community at the same time.

I have been asking all the artists I know how love is involved in their practice. I have noticed a gender split in their responses. Women speak about love as a topic in their work. Men seem to substitute the term love with wonder, questioning or curiosity. I detect a fear of love as irrational or sentimental—uncritical. Recently, I talked to a male professor about loving the viewer, and he thought it was an extraordinary and peculiar concept.

Sending you warmth on a snowy day,
J

PS: What happens when you decide to use love to generate your action in the world?

J,
What happens when I gesture in the world? More often than not, I bleed water.

Your question makes me ponder that fear passing for cynicism can make artists of both genders surround their hearts with a thorny wreath to protect their inner tenderness. Over time, this "protection" can kill their hearts, making them unrecognizable. Artists can lose their humanity (their heart) at the altar of materialism. It is culturally tragic, because their practices can become so successful within shows, fairs and biennials that they increasingly lose touch with audiences outside those venues. As that happens, there is a notable loss of love in their work. Their practices can become self-indulgent monologues, even if they employ the conventions of a social practice, but as mere style.

In addition, there is masculinity, and how it is perversely constructed as disconnected from men's deepest emotions (love), which are feared as chaotic and thus debilitating. American

Minimalism, which is anxiously middle-class, white and male at its core, came to regard all emotion as sentimentality. To make matters worse, this unfolds within the context of an American environment of sentimental entertainment and melodramatic spectacle. It is a very difficult environment for those of us whose practice is about love.

What is love within art making? It is the unapologetic concern for human evolution, from a cultural standpoint, based on a belief in the transformative role art can play in that process. This begins with compassion (not condescension) for audiences, a concern for the well-being and growth of audiences, no matter how different and unfriendly to us. Love first manifests itself in the process of art making as a dialogue with audiences. Love is also about the interiority of the artist. Can an artist make the conscious decision not to take on an aggressive competitive persona and embrace vulnerability as her devastating armor? Can she be humble? Humility is not weakness. Humility consists in the articulation of truth, as Saint Teresa used to say, and truth is very powerful.

As for addressing both the art and the spiritual communities simultaneously, which are currently disconnected, I think that we are on the threshold of great change. Much of what we have been making will soon feel like early Medieval art, very distant and foreign, almost incomprehensible. This great change will be the result of global, economic and environmental changes that will make everyone reevaluate the art that is considered important. Those whose work is about love will survive this historical purge.

Therefore, I would like to coin a new term: the *heartworld*. Americans speak of a heartland. Let's imagine, dream, conceptualize and create a heartworld.

Warmly, on a snowy day,
E

March 12, 2007

E,

I have never doubted the transformative power of art. I believe that most people come to art because, at some point, it has moved them deeply. I have found that if I appeal to this initial inspiration, people will usually meet me there. This has been my way of melting the cynicism I encounter in the art world. In fact, I have found that people long to be reminded of this experience.

I experience art as a kind of communion, a mutual recognition between artist and audience. The artwork is the meeting place. In the work, we see a reflection of our hearts. Why? Because artists have placed themselves there. Is this about Jesus, Buddha or truth? Maybe it is about vulnerability, humility or just the fragility of the human condition. Whatever it is, it is complex. Standing in front of a great artwork is like staring into the eyes of another person. Its dynamic presence meets a flood of projections, a battle of sorts, yielding to a breakdown. To receive its power is to stand open, naked and vulnerable—to surrender one's prejudices and preconceptions, to allow oneself to be moved and changed. Isn't this love?

I live in a very small world. I speak from my limited experience and, at times, to my surprise, it resonates. I can only think that deep down there is a place where we all connect. This is my motivation. What happens in the cloisters or on the meditation cushion, and how does it differ from a more outward approach? What about art as service? It calls us to be in the world. Is making a matter of turning ourselves inside out, exposing our hidden side? I need to know why you left your cloistered life and how that transition worked? I am wondering about the private experience of making and the public experience of showing. How does one move between two worlds and not lose oneself?

I have been thinking about you feeling that our environmental crisis will force a transformation of our thinking and priorities. This makes sense when I look at my own life. Real change has only come

from real crisis (sickness, loss, sorrow). It saddens me that this is what it will take. On the other hand, it makes me thankful for what I have. I can see this happening on a global scale.

I just saw the movie Into Great Silence. Have you seen it?
J

J,
I saw that film with a date and later bought a copy. All performance artists should watch it.

I too have been an artist for as long as I have been conscious. I was a little child artist who was always modeling clay and experienced intense dreams about being underwater, drawing mermaids and futuristic cities that looked like Native American mounds with a myriad of tiny windows.

Yes, people seek to be freed from the burden of fear and anger; they seek to be moved and reminded of their original tender selves.

A cloister is a place that regards itself as the center of the known world. Those who dwell in a cloister feel as if they live at the center of the universe and, in many psychic ways, they do because it is meant to be a place of transcendence out of which the contemplative "travels" to the rest of the universe. It is the most public private place in the world, the most known secret place. In addition, it is a place of interdisciplinary knowledge, of gathering and synthesizing.

I did not leave the cloister; I still remain cloistered deep inside. I carry a monastery within me, much as an exile carries a homeland within him. However, this cloister has expanded to now include everywhere and everything. There is no duality, no inside and outside the cloister wall; no studio and world oppositionality. They are one and the same place.

My performance practice as a social practice forces me to speak publicly all the time, but my silence is not interrupted by words,

because the words are not superfluous; the words come from the silence and do not contradict it. The words are part of the silence. My problem is that I forget the strength of the words, that they challenge people.

We are all drained by the process of art making. Sometimes we need deeper levels of solitude than usual. The wind blew me out of the monastery gates, much like a leaf. It was the wind's idea.

From my heartworld,
E

May 5, 2007 *(Morning)*

J,
You ask so many questions! I plan my life in terms of multiple projects. When we met, I was teaching in New York and traveling to Boston, Chicago and San Juan. That was my map. I could only gaze as far as what was scheduled for the next year. Afterward, there was an abyss. I still cannot envision the future; it remains unimaginable. But I am happy to dwell in a place of not-knowing.

As for my work, it is just a drop in the ocean, as I am. I am unimportant, insignificant. If anything, my body is a riverbed of clay. It waits for rivers to flow through it. It is not afraid, even if they erode it. Erosion may be painful, but it is important because it reshapes old landscapes into new ones.

Yours,
E

May 5, 2007 *(Afternoon)*

E,
Many more questions…

I want to know how you choose your form of expression? How did you move from the old work that you showed me to what

you are doing now?
Are you trying to hold a space for the viewer with your presence, your body?
Do you expect the viewer to enter that space, or at least recognize it from the outside?
How is it connected to a kind of contemplative state that you learned to inhabit in the monastery? What does it mean to perform that state?
What about the objects that come from the performances?
What about your [Boston performance of] glass bottles with water? Is this like the holy water that my grandmother kept in a plastic bottle in the shape of the Virgin Mary? (She would rub it on her forehead from time to time.)
Has that water been changed during the performance?
Literally, or metaphorically? Is it a relic? Is the glass bottle a reliquary?
How do you feel about Joseph Beuys and his objects? Do you buy the myth?
Do you experience the aura? Are you willing to mythologize yourself as he did?
Are you "dressing up" when you put on robes?
Do robes help you maintain or hold space? For yourself, or for the viewer?
And what about the photos? Do you see them as pieces in themselves? Can they do what your presence does, or do they function in another way for you?

I would like to see the documentation from your last performance. Your riverbed is rich. It has collected so much sediment.

Warm currents,
J

May 6, 2007 *(Morning)*

J,
I perform because it is the gesture of the times. It is the only work worth pouring my energy into. It possesses me. After a life of sitting

and hiding (within a cloister, within a studio, within a school), my body has stood and walked me into the public sphere. Maybe it has taken a lifetime to find the courage to do so. Maybe it is because I do not care about what happens to my body anymore. Yet, even as I share this, I am aware that I am standing in the public sphere hiding in full sight. I do so inhabiting a zone. Everyone can see me, but I am in another dimension, there and not there, absent and present, all at once.

You asked about the found objects gathered or new objects produced as a result of walking. Yes, they are documents, props and relics; they are all of the above in the construction of metaphor by way of scholarship, theater and ritual. The *water* is both art material (the material of art) and sacred secular relic; the *water bottle* is both performative sculpture and reliquary; the *water sculpture* is art and altar. And some of it is ephemeral, as it later evaporates, or is poured and returned to the ocean; and some of it remains as archived documentation. Nothing is stolen. Water is borrowed, short- and long-term, in temporary stewardship.

As for the photos, dare I confess that they are one of the places where I indulge in old-fashioned artistic pleasure? Part of me still likes to create a very beautiful image, formally composed, like a painting from the Western canon. But it is also about a concession (a word that I am borrowing from you). I do not believe in traditional conceptual documentation because it often feels cold and sterile. Creating a beautiful picture is part of a residual romantic quality in my practice. I am definitely willing to admit that, at least to you.

Sincerely,
E

May 6, 2007 (*Afternoon*)

J,
I suspect that art making for us is a balance between being animal, human and spiritual; between timelessness and being grounded in

the now; between intense privacy and public concessions. There is a constant negotiation of moments, moment by moment, between performer and public, creating a public entity.

E

About a Robe *May 2007*

It is interesting to me how as Westerners we can accept Buddhist monks in bright orange robes down Sixth Avenue, but we cannot tolerate our Christian visual tradition because some of us rejected it. Because it rejected us. In addition, there is our tradition of empire and our automatic love of the exotic. I remember teaching a Thai student who had been a Buddhist monk for some years back home. He hated the experience of being a monk. It was very painful. For him, those sunny robes elicited the same disturbing associations as black robes do for Christians.

This is neither an argument, nor an apology, but I can list positive and negative reasons why I have performed in robes:

1. Because of my autobiography as a former Roman Catholic schoolboy, a diocesan seminarian, a cloistered contemplative monk and a Catholic Worker community member.
2. Because they protect me, and provide me with a sense of safety. The robes offer one of the few boundaries there are in a medium without boundaries between viewer and performer.
3. Because I wish to confront viewers with an embodied transcendence, and I do not shy away from using religion as culture, as raw material, as the fabric of art.
4. Because of my love of sculpture. For me, the robes are sculpture.
5. Because the robes are not just costume. The robe is a site. The performance happens in and on the robe as it happens in and on a space, place, architecture, land and landscape.
6. Because I am forced to recycle. Others find it easy to commission a fashion designer to design an Armani-styled minimal garment, but I have not had access to those resources.
7. Because I am patient with my body and its decisions. My body

needs and wants to wear a robe right now, so I am not going to stop it. Maybe it will want to dress in bright reds one day.

Genderless Strength

True vulnerability is genderless. But there is a performative architecture of play, failure and defeat that looks like male vulnerability, yet is still part of the masculine mystique. Within that encoded construct, a fallen male character enacts personal failure in public. It is problematic, however, because that character is constructed through the masculine heroic, through patriarchal power. The taller the masculinity, the bigger the fall. Thus, what we are watching is the voluntary or forced epic disempowerment of a male character brought low by his flawed inner self (the bankruptcy of his masculinity), or by greater castrating forces outside his self (as masculine as him).

I believe that true vulnerability in performance is genderless because it starts from none of these constructs. Although there might be a fall, although the body might experience defeat, it is either the result of the suffering of the innocent, momentarily vanquished by injustice, or the vulnerability of human nature as a whole, which can give in when tempted. No human is made of steel; there is injustice in the world; even the just suffer.

The suffering of the innocent is an ongoing mystery that no religion can fully explain. Performance at its best should remind us of this. I seek a genderless vulnerability in my work.

Encoded Whiteness *Winter 2006*

Minimalism is filled with the clutter of whiteness. My body cannot walk through it without being poked, slapped, pushed, kicked, bruised and scratched by its many ethnicities, by the many shades of whiteness, encoded as a standard of excellence, as value rather than as color. Yet, whiteness is a color of many shades. It is such a dense, littered space that my body can barely move and breathe in it. The aesthetic of Minimalism, as a notion of purity, like

racial purity, is such a shocking popular concept that, when I am confronted with it, I cannot but think that the person has been intellectually colonized into unconscious complicity. I have never witnessed something as dense as a so-called Minimalist structure, encoded with everything that is repressed and oppressive. While I welcome and practice a performative visual economy that is monastically austere, Zen-like, I differentiate it from the gestures of encoded whiteness.

Alternative(s) *May 2007*

I admire how Rebecca Solnit refused to go to art events during the Gulf War. I too seek to generate my own art environment. It is an alternative art environment, not of consumers but of socially engaged participants who seek to be transformed rather than entertained, who seek to give rather than collect. It is an alternative art environment of artist citizens who seek to trigger generous epiphanies, and who are willing to share them with strangers in the public square, because their creative processes are a public square where art is the product of relationships with people known and unknown, with people who are like and unlike us.

Remembering Felix

I love how Felix Gonzalez-Torres did not have a studio. He labored over his home table like a humble hobbyist. It made him unafraid of taking risks and making mistakes. I share his notion of a homemade art accompanied by a fearless sense of having nothing to lose. There are none more dangerous than those who live and work as if they had nothing to lose.

I met Felix in 1977. We were both Cuban-American closeted gay boys at the main campus of the Universidad de Puerto Rico in San Juan. Unfortunately for the two of us, the university's procommunist environment was rabidly anti-Cuban. Cubans had been welcomed by the Puerto Rican government during the 1960s as refugees from Soviet-style communist Cuba. They were perceived as white middle-class professionals who would contribute to a

burgeoning society in need of more bankers, doctors, architects, engineers, advertising executives and teachers. Because they were industrious and the island environment was familiar, these Cuban-American exiles quickly set themselves up as a new light-skin elite. What no one foresaw was that they would also turn pro-statehood, quickly becoming enemies of the pro–Puerto Rican independence socialist movement.

Therefore, Cuban Americans were extremely unpopular at the university. Not that there were many of us. Most Cuban-American families sent their kids to study abroad. So, Felix and I had to walk every morning by propaganda murals and graffiti with slogans like *Cubans Go Home! Cubans are Worms!* And if our fellow students and professors discovered that we were Cuban American, we would be discriminated against, ostracized. It was an oppressive environment that made us twice-closeted, and while we both suffered privately, we had different public responses.

I chose to study the Puerto Rican anticolonial position, talking with communists who hated me to my face, to whom I wanted to prove that I was not the enemy. Felix decided to leave. He left in 1978, deciding not to complete his undergraduate degree there, but to transfer and finish it in New York City. I remember Felix's frustration and anxiety. *We have to get out of here!* he exclaimed. Those were his last words, and then he was gone. He looked sad. Indeed, many Cuban families left Puerto Rico for Miami during the late 1970s, fearing it was just a matter of time before the island became a communist republic like Cuba. So Felix left, and I stayed behind, trying to understand. And although I was never accepted, this early political fieldwork would provide critical training for my future performance work as social practice.

I returned to Cuba during the 1990s, staging four projects hosted by the National Union of Artists and Writers at various official and unofficial spaces. I spent many hours speaking to communist officials at every level, from neighborhood watchmen to the Minister of the Exterior, trying to convince them that my art projects were not counter-revolutionary. And I did.

Trying to understand what was happening outside the art world among people who thought modernism was the result of bourgeois self-indulgence, or simply irrelevant to their lives, has always been an ethical concern. I also worked with blind college students during those same years; many of them had become blind from childhood diseases for which their families had not been able to afford treatment. Their bodies were noticeably smaller and thinner than mine. My body felt voluptuous and gigantic among these little blind birds. I remember not only reading to them, but also escorting them through campus.

Those blind kids slowed me down: they slowed my walk; they taught me how to walk mindfully of others. They could not afford seeing-eye dogs, so they relied on walkers as new courses took them to unfamiliar parts of the campus. Their bodies clung to mine without any social boundaries. I felt their bony fingers and ribs against my larger, fleshier arms and well-fed torso. They were uninhibited about touching me. In fact, they often asked me if they could touch me to know me. I did not know it then, but my future bodily practice was being forged. Every performance-art student should do volunteer work with a handicapped population. It would be part of my body curriculum.

Documentary *August 2007*

I watched the documentary *Walking to Werner* at the Anthology Film Archive, which featured a dialogue with its director, Linas Phillips. The film is the coming-of-age ritual of a young man who has a glimpse of greatness but is too dense to learn from it. Even though he walked hundreds of miles along the West Coast to meet the director Werner Herzog, he never learned how to walk. He walked like a duck. He never saw the landscape; it never evolved beyond a flat backdrop for the human character. He never immersed himself in it, even as his last images are those of him walking into the Pacific Ocean up to his neck, camera in hand, negotiating the waves, partly driven by something unconscious that sought cleansing. It feels like a profile of a generation disconnected from nature. Perhaps he meant it to be humorous, but I thought it

a tragic waste of a pilgrimage.

Weeks later, I watched Mathew Barney's *Cremaster 2* at the same venue, and I liked it much more. I found it to be unpretentious, imperfect, given to accidents and spontaneous human gesture. It became visually obvious that he was seduced by the epic quality of the Utah landscape, not just the Salt Flats, but also the mountains. In the end, they dominated and became larger than the human story, more important than the cremaster metaphor. It was beautiful to see Barney so permeable, less Sphinx-like. While *Walking to Werner* was a parody of pilgrimage, *Cremaster 2* was a sophisticated sketch of America's stubborn violent innocence.

Followers Following September 2007

A close friend tells me that she was surprised by how hard it was to follow me during my Boston Harbor walking performance. She did not expect that she too would be on view because of me; that people would be curiously watching her following me, walking with me. We were a unit, a body, a company. We had become a performance group, and she was one of the performers. It was our collective performance. So yes, there is a price for publicly following a public performance.

Unlike the walking performer, followers can negotiate their levels of performative complicity, in terms of the distance they keep from my body, so as to undo the gestalt. Are they close enough for others to notice that they are following me? Or is the following not exposed but kept publicly secret? In this case, the follower is more of a voyeur, and it is not as interesting to me, nor as effective, though the experience still has value and impact.

However, if a viewer dares to be my accomplice, then, the foolishness expands, i.e., there are two public fools, the no-body walking no-where and his follower, the fool's apprentice. Both are vulnerable, even as both are protective of each other; even as both are locked into a public dynamic where they cannot protect each other fully. It is a wonderful performative tension that elicits a lot of love.

Recognizing Performative Moments December 2006

A. Life as Art

It became unexpectedly cold late last night, but my new boyfriend was not wearing enough layers. Although he has a hard time accepting help from others, his walk home was so long that, for the first time in our relationship, he asked me for help; he asked if I could spare a layer. (I am always cold and thus overdressed.) So I happily gave him my vest. The next day, while we were riding the subway, reading next to each other, sitting no closer and no farther apart than typical commuters who are strangers to each other, he suddenly looked at me as if remembering something. He then spontaneously took off his coat, silently removed the vest he was wearing underneath and gave it to me. In an equally spontaneous silent response, I suddenly took off my coat and put on the vest. We did not exchange a single word during the exchange. The gestures were understood between us. We performed the exchange quickly and mechanically. We did not utter a word afterward; we went back to reading our respective books. But I suddenly noticed that everyone around was looking at us oddly. They had become an audience. We were two strangers spontaneously performing a baffling gesture of generosity without explanation.

B. Fiction Follows

Two men sit side by side in a white room. The first is partially clothed and cold; the second, well dressed and warm. They dress and undress in silence, sharing garments in silence. It is slightly dramatic, as they take turns being increasingly cold. You can see the steam coming out of whoever's turn it is to disrobe. This is a proposal. I pull out a blank postcard, make a small sketch of two figures behind a beautiful wooden table on which their clothing is laid out carefully in-between the exchanges and write the following: an idea for a new performance in which one man sits vulnerably in his underwear next to a second man who is stylishly dressed. The suited man strips down to his underwear and places everything he was wearing very neatly on the table before them, laying it out like the outline of a third man, a sculpture, the *body of compassion*. The second man dresses himself. This is endlessly repeated, back

and forth, until they start becoming visibly tired, or until both feel cold no matter if dressed or undressed. But is this the end? Does it simply stop due to exhaustion, even if one of them is dressed and the other is not? Or do they both end half-dressed? I like that: they both end partially dressed. But what is the title? *Unison?*

C. Still Ruminating (Nine Months Later)
Or are they a man and a woman, both dressed? (Janine would like that.) They both undress and dress in each other's clothing, successfully and unsuccessfully, humorously and pathetically? It ends when they are both exhausted and he is dressed as she, and she is dressed as he. But what is the title? *S/He? The Impossibility of Getting to Know You? Sibling Lovers?*

Project Continuity 1

I first met Saralyn Reece Hardy at the National Endowment for the Arts in Washington, DC. She later commissioned me to do a project about her Kansas people and landscape. I created a piece titled *Becoming the Land* for the Salina Art Center. Saralyn is a true citizen curator; that is, her curatorial practice is deeply rooted in her central Kansas farming and cattle-ranching communities and is committed to connecting them (if not the entire Midwest) to the rest of the world. She and I have been speaking about the need for the continuity of site-specific project-generated relationships. It is hard to know where her voice ends and mine begins, and vice versa. We have developed a common vision in which we finish each other's sentences.

After the ground-breaking work of creating a truly sited performance piece, both adopting and being adopted by a community, it seems completely counterintuitive, outright illogical to suddenly leave, to run out of town like a burglar and never come back. There should be a return, a revisit. Otherwise, no matter the depth and complexity of the piece, no matter its social intentions and success, it is still operating within the realm of spectacle. We need long-term relationships with communities. In my experience, when I have returned to a community, not only is the

groundwork already done, so that a second project is much easier, but people are moved; they are happy to see you again, like a long-lost son or daughter. They want to show you what has changed, what has been built or torn down in your absence. They want to share their memories of you; they want to know your memories of them. What survived the experience as you kept on traveling? They feel valued, important, worth going back to.

If I could return to Kansas, I would do an early morning or early evening walk (depending on seasonal light) for a duration to be determined: a week, a month, a season, a full year. I would walk a stretch of land every day (ideally) or once a week at the same hour. People would at first be surprised by it, amused or annoyed. Eventually, they would come to regard the performer as part of their landscape and begin to ignore him, noticing him only once in a while. Or perhaps they would begin to look for his punctual gesture like a clock marking time. Of course, this implies a commitment by the performer to the place. As for meaning, other than the purely meditative, the creation of an embodied flow into which meditation about anything and everything can be inserted, it would depend on what is going on in the state, region or country at the time.

Performing Loss [*San Antonio*] *Summer 2006*

I spent much of my childhood crying alone or in front of others. It was humiliating. I used to think that I cried enough tears for an entire lifetime, so that by the time I reached sixteen, I told myself that I would never cry again. I felt dried up. Indeed, as intense relationships came and went, I did not cry (past lovers remarked on this), not even when experiencing great loss.

When I was commissioned by Rene Barilleaux, Chief Curator at the McNay Art Museum, to create a site-specific performance to accompany my *Walk #1* exhibition project in June 2006, I began to gather images of the conflict in the Middle East, particularly from the evening roll call on the *PBS NewsHour*, in which the faces, names and ranks of dead American soldiers were finally shown to

the general public after their identities and photos were released by the US Army. The *NewsHour* was the only daily program that I knew was doing this, rather than hiding our dead for fear of being labeled unpatriotic.

In addition, I also gathered the painful memories of my childhood, long put away in my mind. Toward the end of the process, as the performance drew near, I felt like I was casting a spell, conjuring a hurricane. Nevertheless, I constantly held all the images of the dead and my painful memories just close enough, keeping them like a group of wild creatures in a padded cage on wheels that I pulled and took with me wherever I went, not letting them fade back into the past, but also far enough so that they would not depress and destroy me. I lived like that for months; everything was ready to surface and explode unleashed. Finally, on opening day, I requested the museum's old theater to prepare for my performance in the garden. The theater was cold, dark and empty. The stage was like a vast field, the open curtains revealing a sea of seats. I made a point of arriving and dressing early. I wore a long white robe and white makeup. (Butoh influenced my first major live performances.) I purposely began a private performance to no audience. I wanted the performance to start long before anyone saw it, so that when it finally reached the public, it was already in full swing, all gestures refined, all emotions on the loose.

I began to walk in the darkness, repeatedly making a circle, refining my few allotted gestures, as I had settled on just a few, very close to the body; counting all the images and memories gathered, inventorying the denizens of my padded cage. I requested theater director and friend Tim Hedgepeth to watch me, to further advise me about gestural containment if necessary. He was an advocate of less is more, to which I subscribed. Tim acted as my coach, incredibly generous and sensitive, sitting at a distance in silence throughout, his hand covering his mouth so I could not read his reactions, letting me explore, develop and deepen my experience to its preclimax. Meryl Streep has rightly said that there are characters who are dangerous to visit with one's body. But I think that performers do not visit characters as much as channel forces.

Minutes before the start, Tim carefully waved at me, indicating it was time to go. He brought his car to the theater's side door. I stepped from almost total darkness into blinding Texas summer sunlight, and he drove me to the museum garden, to the foot of a wooded hill crowned by a tall fountain, where a large stone circle awaited my walk. I climbed a narrow path of weathered, cool stone stairs through trees and approached the spot like an apparition in bright sunlight. It was very hot. I could hear loud voices and the clinking of wine glasses from the cocktail party unfolding on the upper lawn of the museum. As I left the shade and stepped onto warmer stones, I finally unleashed all the images and memories and began to cry for the first time since childhood.

I repeatedly walked the stone circle while the party crowd saw me from a distance, grew increasingly silent and began to walk over to join me in silence. I cried uninterruptedly for the entire duration of the performance. It was as if a deep reservoir was emptying itself out and nothing could stop my uninterrupted flow of tears. The crowd held its breath. You could hear a pin drop. I could only hear my own sobbing and the sound of water as the fountain forced it very high into the air, subsequently falling along its surrounding low wall. In the end, I walked away still crying, even as I climbed down the steps alone back to Tim's car. It was only when I stepped in, sat and found myself beside him that I stopped crying, looked at him and suddenly laughed, swallowing my own tears with joy.

Reperforming feeling
we are found by feeling
we recover feeling.

TZOFIA performance, digital image by Jan Tichy, Tel Aviv, 2008

> *The methodology of power is anxious, exhausting and incomplete. The methodology of vulnerability is much more thorough, in terms of the psychic disarmament I hope for.*

Chapter Four ***Vulnerability as Methodology***

Barefoot Body of Not-Knowing Fall 2011

There is no democracy without art. The American democratic experiment needs creative critical artists so as to assure the sustainability of democracy in an increasingly diverse, economically impoverished society. The urgency to make meaningful art needs to be matched by the urgency to form artists as citizens who move other citizens to reflection, through art making or through presence.

I am a public performance artist and social choreographer, site-specific to the point of being a cultural portraitist, one people and one landscape at a time. I work in the tradition of American photographers of the late nineteenth and early twentieth centuries, roaming the Midwest and the West with their tripods and camera equipment, taking pictures, portraying homesteaders in isolated communities, unemployed single workers, impoverished families during the Great Depression. That is what I have become and keep becoming: a student of people and place the moment I receive a commission.

In addition to this cultural portrayal, I am interested in the notion of the artist as citizen, of the artist as a cultural worker. Because in a world where much is bankrupt, from ancient to more recent religions and cults, art retains the power to gather, inspire, inform and transform audiences. American democracy cannot survive within an increasingly racially, ethnically and culturally diverse, financially challenged overpopulation seeking opportunities and alternative resources without silent space for creative critical thinking. My performance work consists in creating such spaces and times and offering them to the public.

I begin to research a place from a distance, nevertheless trying to connect to something and someone. I need that connection. I look to the past for lingering explanations of the present, particularly the problematic. Everything and everyone is densely layered; there is much more complexity than meets the eye. Nothing is seldom all evil, or all good. People love what they hate and hate what they love. I seek those contradictions and subtleties for my performances, for my body to perform, to be displayed across the canvas of my body, informing its steps, pauses and gestures.

This process leads to scholarship: interviewing experts from disciplines relevant to my project and selectively sifting through countless volumes of historical, modern and contemporary information, as before a major test. I know that I take in more than I will eventually retain. I am informing mind, heart, body and soul. Every part of what has been termed my human beingness must be addressed and informed, so that I arrive at the performance knowing almost all I need to know—which is to say that I must know enough to begin gesturing while letting the performance itself fill in the rest.

When the moment is over, much of this quickly accumulated information begins to dissipate quietly, and I accept the loss. I expect it; it is an inevitable part of detachment from place. It is what happens when one stops studying a second language. But even if I tried, I do not know if my mind could retain it all forever, project after project. (Immortal memory seems to drive insane the characters of writer Anne Rice.) No one can be a walking library of all knowledge. So I learn the limits of my brain each time, over time. And I learn the depths of my heart, which has proven bottomless so far in its capacity to fall in love with people and places, and keep on loving them long after the fact. I may forget dates and facts, but I continue to love a landscape once I have performed there.

Over the years, I have not only come to trust my instincts and intuitions, in terms of my unconscious, but to greatly rely on them. My unconscious is like a second body, like a bird or a dog. It circles

me, it runs around me, in and out of me. When I am commissioned with a new project, I tell my unconscious about it, as if it were a separate entity, as one telling a story to a listener. In many ways, it is like planting a seed or dropping a pebble into the bottom of a dark well hoping it grows into a Tibetan underground mountain.

I address my unconscious and ask it to begin to conceive, create and construct something. I entrust it with conception, gestation, crafting and polishing. Indeed, it is a common experience for a work of art to spring fully formed out of the unconscious. My consciousness is given great tasks, and I proceed knowing that I have the best of studio assistants, perhaps a whole team, for who knows all the voices that populate an unconscious. It is like triggering parallel processes, parallel bodies deep-sea diving, distance swimming, walking, racing, jumping, flying. I know that they will meet at some point, but I do not know when. I live in this not-knowing in peace. I trust it; I trust what lies deep within me to arise and join what lies closer to my surface, more obvious, more observable.

I visit a place not only foundationally prepared at the conscious and unconscious levels, and I then add on what I call the "field animal" and psychic levels. I enter the place much as a nonhuman enters space, seeing, smelling, listening, touching—sensing. I unleash all my senses, favoring those that have not been engaged so far, like smell and touch. Touch immediately begins to happen, through hands that caress all accessible surfaces; through a body that feels dryness or humidity, hot or cold; through the feet that walk smooth or textured, horizontal or vertical terrain. My body is a sponge.

The psychic visits too. But the psychic is the most unpredictable of all my sensors, even more so than the unconscious. And this is where the rational Jungian definition of the psychic and a more indescribable experience suddenly part ways. Therefore, if there is a ghostly residue, a ghostly presence, a lingering intangible pain, suffering or hate in the place, I sense it, pick it up, feel it, see it, like a dusty breeze or old wallpaper. It is yet another level I absorb to inform my performances. But the art world hardly ever addresses

that level because it is not a level found within the architecture of galleries and museums, but within the messier architecture of the human condition.

Over time, this has become an increasingly important level, sometimes the most important. I started out ignoring and hiding it. But more and more I put it at the forefront of a piece, partly to honor the dead, partly to resolve the unresolved, to heal what remains unhealed among the living and to strengthen the piece with elements that are clearly not from me, from my academic research or my field-animal instincts. They emanate from the place itself and demand my attention and inclusion in the performances.

When I arrive in a place, I immediately form a production team. In fact, I try to begin forming it long distance if I can, before my arrival, communicating to people about the need for such a group, preparing my host institution to open and share our project's process. I never rely solely on an institutionally based director, curator or educator. I need a lot more help than that, and a very different kind of grassroots help than what institutional power provides. But I also wish to decentralize art-world power by creating an interdisciplinary process that generates previously unimaginable collaborations, that promotes local and regional artists, resulting in a transparent and thus accountable process.

I consult with these individuals and seek their stamp of approval, even their permission. Of course, this is also a strategy for creating site-specificity, as those professionals are the site's embedded network of checks and balances, the first line of review and critique as to whether a piece is truly site-specific (an accurate cultural portrait of a people and place). But even as I share my authority with others, I maintain much and receive even more along the way because there is a project clarity of vision that must be maintained, even if flexibly. My advisors inform it, but they follow it too.

My advisors are invaluable, because in addition to being the embodied information, knowledge and wisdom of a place, they open doors as gatekeepers, doors that my body could never open on

its own. Advisors also serve as a project's first audience. Whatever I am ultimately going to perform in front of a local, live, mainstream audience will be performed before them long before others see it. I cannot imagine making a public piece without feedback from such a critical body of supporters.

After my advisory group is formed and functioning, the next crucial body to form is the performance's inhabitants. (Sometimes the formation of both overlaps.) I create an ephemeral company of performers, a temporary troupe, wherever I go for as long as I am working there. This is usually the result of a selective recruitment of artists by the project's host that begins long before I arrive at the site, as well as an open call to a wider community once I get there.

The first wave of recruitment happens based on people's long-distance perception of me and the proposed performance. My recruiters on the ground begin to recruit based on what they have read about me and presume I will do. Usually, they have not met me or experienced my training, so some of their preconceptions may be inaccurate. As is to be expected, they tend to look for performance artists and art students. I encourage them to also recruit actors and dancers. But because there is very little cross-over between the performing-arts and the performance-art worlds, and became my recruiters often do not speak their language, I hardly ever arrive to find actors and dancers among my first line of performers.

The moment I arrive into what has been a very controlled, neat and safe process, all bureaucratic constraints suddenly break loose. I begin to recruit "lay/secular" people no one expected me to engage. I want to promote local and regional artists; I want to be interdisciplinary, recruiting from disciplines outside the art world; to include ordinary people, parents and grandparents, awakening and reawakening dormant talents. I want art practice to be generous.

I also never forget the fact that my second audience, after my production team, is my performers. In fact, a durational group performance is only going to be fully witnessed by the people who

are performing in it. Everyone else will go back to work or go home to rest at some point, only experiencing a piece, a part, a fragment. Therefore, I want my performers to be as diverse as my audience because they are often going to be the only witnesses to some of the most important moments during the performance. They will carry the memory of it, and I want that memory carried as diversely, as far and wide, as possible.

When I teach a performance studio course as part of a performance project, I train my students for weeks. They will work on my public project at all levels, but they will also be required to develop individual performance proposals curated by me. It is a very rich experience of full immersion. In addition, if I also manage to recruit members of the community through an open call that has jumped the art-school campus gates, or if I am sited in a museum or contemporary art center with access to a lay/secular membership, I will train several groups in parallel, but on different days, times and locations. For all groups, the training will be based on trust, on meditations about vulnerability as the key to opening our sight to a place, on detailed directions about walking, stillness, silence and the goal of transformation.

Am I concerned about an unevenness of delivery? Yes, I do not sleep much during a project; my sight is like a laser scanner, constantly scanning its surface and underground recesses, the visible and the invisible, repeatedly revising every detail. But I patiently encounter everyone's concern for artistic quality in three ways. First, I rely on my performance-art students to be the core group: a core group that is empathically vigilant, supporting everyone else. Second, I never assume that the art professionals who have received more training from me are going to be better performers than those who have received less. I have often been surprised by the admirable performances of so-called lay/secular participants. Third, I accept that the very nature of the social choreography, the social sculpture being created, demands the diversity of human experience.

I now write a *Performers' Manual* for each group project, although I have a basic template that I wrote for a Chicago performance

in 2006 and developed in Salt Lake City in 2010. It starts with sharing parts of the project proposal written for that specific site, in terms of story-telling and foundational training concepts. This is followed by meditations about silence and stillness, walking and gesturing exercises and field tasks. I write as detailed a manuscript as possible.

I then convene a first meeting in which I formally read the manual out loud to would-be participants while also responding to what is spontaneously happening in the room. That first reading of the proposed durational group performance has the secret capacity to bind and challenge the group around an urgent common vision. That reading also has the capacity to edit out all those who were there for the wrong reasons, or for the right reasons, but for whom the task at hand is too monumental.

People walk around with unarticulated needs. They walk around with life-long yearnings, with profound desires. That is why words grab hold of them. All it takes is for me to read out loud a few words about memory, meditation, silence, revisiting a place, revisiting themselves, and they are seduced. They are seduced, however, by their own secret longings, by finding what they have been hungry for. I am but a mirror to their latent interiority. There are lots of hungry people. Many are starving in our cities. Repeatedly, I watch how they bring their starvation to a project, how they eat the performance. They pour themselves into it. The project is like a generous vessel: it accepts them and absorbs all the lonely people who wish to connect, first and foremost with themselves, then with others and finally with a place, anew.

I become a sign, and the performers become a sign. We are a sign pointing toward what people seek: a profound groundedness. We are a sign pointing to a place and its deeper meanings, sometimes to its unspoken dreams of liberation. We are nothing but an excuse to revisit place.

Throughout the process, the group and I will visit the site we hope to engage. If there are multiple sites, I will personally visit each and

every one with its assigned performers. In this case, I try to match performers to sites based on personal and professional histories as related to site histories. I also ask the performers to visit the assigned site on their own. They must develop their own individual, private, intimate relationship with the site. They must research it. They must know the site as they know their face. The face is the part of the body that we generally know best, much more than the palm of our hand. They must discover things about it that I do not know, that the group does not know, surprising each other.

If I receive enough funding and in-kind technical assistance, I will document the production process through a website. This is challenging, because it results in the creation of a temporary blog between the performers, and between us and the community. But this blog is not a public space. It is an extension of my studio and classroom, so I exercise an editorial responsibility. The performance project will continue to edit its participants throughout its production process. I meet individually with every performer, asking them to tell me their life stories. I want to know where they come from, where they are, where they want to go. Nevertheless, I do not ask my performers why they desire to perform in my piece. I accept them at face value—I trust them. But I also trust the piece. If they are not right for it, as I have said before, the piece itself will edit them.

Although I evaluate all my public performances, I do not rush to ask my performers what they got out of it. I want for the passage of time to curate it in their mind. I want it to turn into memory, to be filtered by time and distance, so that the flow of life itself teaches them what it truly meant. As educator David Henry said at the end of my Boston piece, *The performance is over; its truth can begin.*

What washes through the performers during a durational performance? Sometimes I seek an empty mind; sometimes I engage in meditation. It depends on what the performance seeks to achieve as a portrait of a people and a place. Sometimes I enter a performance planning to be sad, to mourn all day or all night long. But then, I am surprisingly happy. My body is pure joy. I

cannot contain it. It cannot contain itself. It wants to walk fast, smile and look everyone in the eye, like a hyperactive child. On the other hand, sometimes I plan to be happy, and may even start the performance happy, but my body becomes increasingly angry.

That was the case during my performance at the Honolulu Academy of Art in June 2011. A number of visitors related to me as their lunchtime entertainment. I had given my body a very narrow small path to walk back and forth along part of the academy's café courtyard. I was on a high ledge flanked by Japanese ceramic artist Jun Kaneko's *Four Dango* totemic sculptures on one side and a pool of still water on the other. What was meant to be a walking meditation became the path of the panther. I behaved like a tiger in a cage, my body refusing to be perceived as spectacle. It could have roared. Some say that I should have foreseen this inevitable outcome, but I disagree. I do agree that colonial bodies are to be reckoned with, but I remain hopeful about disarming them one day.

In my experience, silence during a durational performance is disarming. It not only creates an expanding space inhabited by performers, but it has a body of its own.

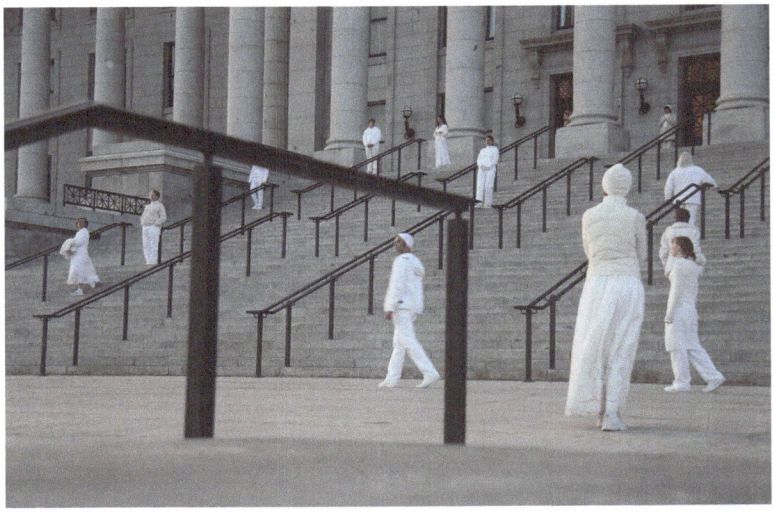

Awaiting performance, digital image by Ed Bateman, Salt Lake City, 2010

The body of silence has a profound stomach with teeth that can bite, chew, suck and swallow practically everything and everyone. During our 2010 Utah performance, a disturbed young woman screamed one of the most blood-curling screams I have ever heard. But my forty-plus performers did not flinch. They kept walking silently; they remained focused and still. They did not judge her. The performance remained undisturbed and she walked away peacefully. The deep silence of the performance swallowed her scream, her pain. It was cathartic. But in Hawaii, colonialism has fashioned a culture of storefront spectacle, so my silence felt like yet another spectacle.

The silence of a public, durational group performance is not a monstrous body with a monstrous stomach. It is the silence of nature, able to encompass the chaos of humanity. It is the silence that we normally find in great spaces—the Grand Canyon, the top of Mount Rainier. The performance is merely bringing that great silence into a city, conjuring and siting it within the urban. If the performance is able to withstand any beatings, it is because it is embodying the silence of nature.

I have been through everything in my mind since it was emptied in a monastery years ago. During a twelve-hour performance, I have sometimes managed to sustain that state of emptiness, of no-mind. But I have also allowed myself to revisit my past, to revisit my relationship with loved ones, present and lost. I have stood above and looked across a city, like a sentinel. I have prayed for it, cursed it, saved it, destroyed it and rebuilt it.

Lately, my increasing double role as choreographer and performer has made me hold the space for everyone. I begin and end the silence. I exemplify the silence. I exemplify the walk, the pauses, the gestures, the form, the formalism. I take care of everyone, the weak and the remarkable, the tired and the energetic, the sleepy and the awake. I walk by them; I walk with them. I follow them; they follow me. I imitate them and they imitate me. And if someone is disruptive, I am the first one to stand by the disruptive person, like a shield, a wall in-between that individual and my performers.

I stand humble but indomitable, not so much shutting them up as muffling them, so that my performers hold their form, and go deeper into their silence. I am the silence that can be sacrificed because I live a life of silence, whether I am performing or not.

What do I want my performers to experience? It may sound simplistic to say that I want them to be transformed, but I do. It begins with experiencing isness through silent stillness. I want them to be in a place the way an animal is, because that experience can trigger the beginning of great personal freedom. Nevertheless, what my performers do with that silent period is something I can encourage but not determine. I know that they will experience something. Some will struggle violently with egos that insist on sustaining a guarded, even angry, stance of cynical disbelief. The luckier ones will struggle patiently with their minds, methodically trying to quiet and empty them. And even though this may end in repeated failure, it will be a victory in awareness, because it will make evident the unwillingness and even inability of the cluttered, noisy, fast, fearful, dominant mind to let go, even for a few hours, and this will be disturbing and unacceptable. It will open their appetite for silence, reflection and inner peace; maybe even for the pursuit of goals once abandoned.

I also want to turn the viewers into performers. I want them to expand our silence. If we are able to draw the attention of pedestrians, slowing them down to a stop, to spend whatever time they can with us, they will initially become our cloister walls and eventually become added performers. I will consider the piece successful if those pedestrians, who must resume their lives, leave but later return with others, having recruited them.

Finally, we must constantly remember that this is a durational piece in which I am using the arc of nature, in terms of the natural passage of time as evidenced by light and darkness, sunrise and sunset. Therefore, it is an unconsumable piece. No one can own it, buy it or take it home in their pocket. They can only experience a little or a lot of it, but not all of it. Not even the performers will experience all of it, because performers take breaks.

I plan closure events after each performance: an informal dinner, a lecture followed by conversation, a town-hall meeting. Nevertheless, by the time the performance project is over, inevitably, I have fallen in love. I want to move to that remarkable place; I want to die and be buried there. I perform in Salina, and I want to spend time in a homestead on the open prairie. I perform in Salt Lake City, and I want to perch on its surrounding foothills, filled with the ghosts of pioneer women. I perform in Skowhegan, and I want to farm. I perform in Honolulu, and I want to sleep by the ocean's roar. I perform in Charleston, and I want to walk knee-deep through the muddy lowlands. I am sited every time.

A monk living by the Rule of Saint Benedict, as I once did, makes three vows. He promises obedience to all, conversion of manners (a performative vow that recognizes the importance of gesture as the outward sign of the interior life), and *stability*, that is, to live in a specific community and place for life. Even though my monastic vows were once canonically annulled in order for me to legally leave the cloister, to return to the world, I have always felt that my former vow of stability is reactivated every time I work in a place. There is a great psychic cost to itinerant performance practice. My heart breaks; a piece remains on site, whether people know it or not. I walk on incomplete, my psychic body increasingly scattered. I yearn for those places inexplicably, as if I had been born there.

I once said to curator Mary Jane Jacob that this was a hard practice, a barefoot practice. I have tried to do it as a public fool, as the town fool does: morally, by the sheer will of supporting consciousness, hoping the effort becomes contagious. My practice has had a very organic path. It has been mostly a process consisting of a trusted waiting to perform. Venues have knocked because people and places need nurses and doctors of metaphor. I am not sure how much good Walt Whitman did as a nurse to Civil War soldiers in Washington, DC, but, in the end, the symbolic value of what the poet did as a whole is more important to the American imagination than any single soldier he helped. The poet nursed men.

I am most alive when I perform. Critics and audiences think that I

am performing some sort of silent mourner or witness. And while this may be true, depending on the commission, I am ultimately performing my thisness. It is not an act, a choreographed ritual, a costume (a drag), a temporary persona. I perform the no-self in whatever stage of evolution it is at that moment. The performance is who I really am. I engage performance as a moment of revelation. In-between, there are various daily practices that remind me of who I really am. I fast daily, only consuming one meal a day; I practice seven hours of silence daily; and I take one mindful walk. I need these practices in order to perform without an armor, vulnerably.

Educated Not-Knowing — Fall 2008

There is ignorance and then there is *not-knowing*, an educated not-knowing that is understood as willingly giving up control, temporarily suspending all previous thoughts and further thinking, so as to allow our instincts and intuitions to lead our performers' bodies into previously unimaginable sites filled with gestural possibilities. Nevertheless, though beautiful, we remain in control of these suspensions, we remain masters of their beginnings and ends. But not-knowing has many more layers of depth.

There is a deeper not-knowing when we suddenly lose everything indefinitely. Our bodies stand without tools because they have proven inadequate. We face a crisis of the intellect because our information has proven useless. We feel lost; we are lost. It is a brutally terrifying moment, a kind of death. Yet, this darkness is where the source of true knowledge resides through the beginning of detachment from all—the birth of wisdom. Here begins the rest of our lives, the better part, as traveling performance artists.

The Zen of Performance Art — Summer 2009

I conceive of the Zen of Performance Art as a psychic manifestation within an urban context. It repeatedly walks, pauses and gestures silently amidst noise, in the spirit of the monastic hours, from a place of suspended thought, of willing no thought amidst distractions. It sustains stillness in the midst of speed. Though sited

in a cluttered place, it is aware of no inside and no outside; of no-one and the totality of One. All humans are one, and all sites are one; performer and site are the same.

Nevertheless, sometimes the Zen of Performance Art may be about thought as an act of generosity, in terms of walking as meditating on a people and on a place. Because there is a crisis of people and place, it allows for the opening of sight to communicate insight.

There is no knowledge without the body.
The body is the path to knowledge.
The body is the only knowledge.
The body is knowledge.

Vulnerable Walkers

My strength is my vulnerability. It is the key with which I open and close space. It is my map through space.

In 2008, I choreographed a performance entitled *TZOFIA* atop the open balconies of the Fredric R. Mann Auditorium of the Israeli Philharmonic, Tel Aviv, with a troupe of five performers, in collaboration with sound-and-light artists Ariel Caine and Jan Tichy. Men and women dressed in Sufi skirts walked the balconies of the modernist building from 8:00 p.m. until sunrise the following morning as the city flowed continuously around us. Our slow spiraling was hypnotic to performers and viewers alike.

Nevertheless, in a city trying to be a secular space within a religious state, my performance project was held suspect. It was extremely hard to recruit Israelis, who wanted no more religion, Jewish or Christian. I told them I promoted none, not even Buddhism. I argued for the human desire for transcendence. I envisioned performers spending an entire night, from 8:00 p.m. until sunrise, gazing at the city, gazing at the future, at the inextricably intertwined future of the Israeli and Palestinian people. There was no future without each other.

The morning after our all-night durational performance, in spite of our exhaustion, we gave a presentation to the MFA Program of Bezalel Academy of Art and Design, which had hosted us. Packed into a standing-room-only empty gallery, all the graduate art students who had mistrusted me until then suddenly wanted to know how I had done that. They had experienced some sort of intellectual or even psychic disarmament; their cynicism had come undone. The performance had managed to captivate them at some indescribable level. Its "fiction" was believable.

I responded that the performance was more real than they imagined. We had spent nine hours walking: nine uninterrupted hours of nonstop circular bodily flow within a giant rectangle. And we had gone somewhere. We had arrived somewhere. Did we arrive in Jerusalem? Did we arrive in Gaza? Did we arrive in the Dead Sea? Did we arrive in the Promised Land? I did not know, but we had travelled somewhere, and arrived. I understood that they were a people under siege, but I believed that they should not be artists under siege.

Several days after the performance, art critic Ruti Drektor wrote on her website that, for the first time, an American artist had come to Israel and, rather than taking sides and further polarizing the situation, rather than supporting Zionism or the Intifada, had held a neutral peaceful ground, a meaningful ambiguous ground where everything was possible. It was the best performance review I had ever received. My response was that vulnerability achieved this.

There was a point of no return when I discovered that I did not know where, what and how to perform except in a place, about a place, through a place. At that point, I had found my identity as a performer, and my edges.

Part 2

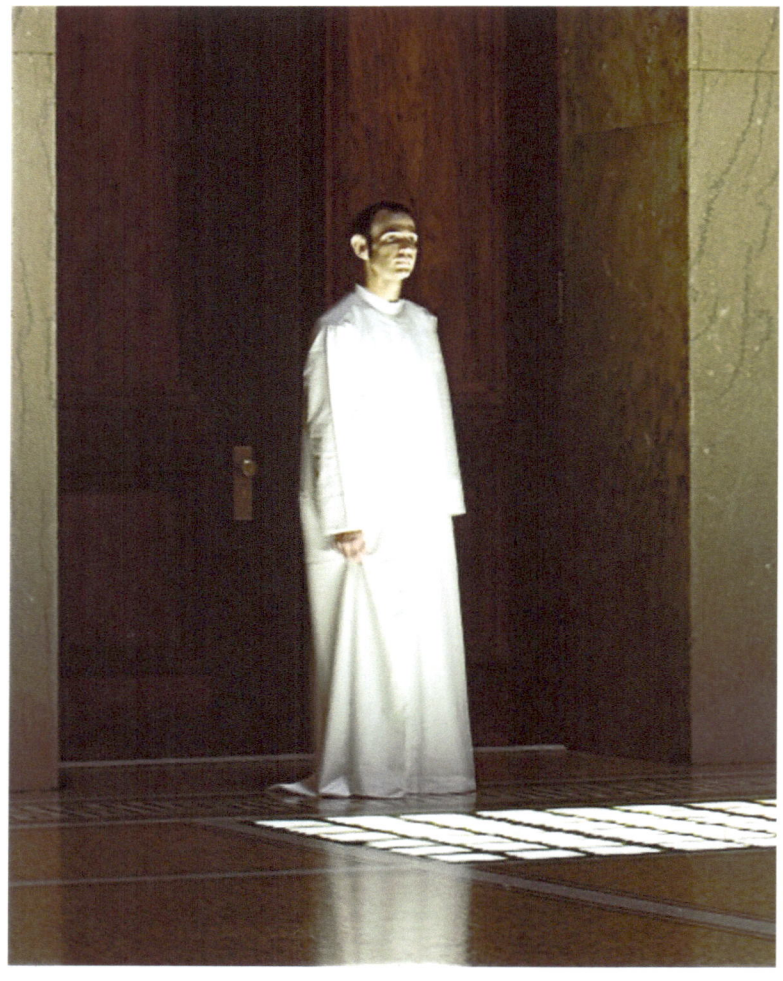

Memorial Gestures performance, digital image by Peter Coombs, Chicago, 2007

> *Mourning is a human right. A nation that does not mourn does not let its citizens and veterans heal. Public mourning could give the American body back its morality, and its moral standing in the world.*

Chapter Five ***Absence Through Presence*** *[Chicago]*

Embodying Loss October 9, 2007

In January 2007, the Chicago Department of Cultural Affairs commissioned me to create a new site-specific public performance for the Rotunda of the Grand Army of the Republic within the Chicago Cultural Center. The performance would inaugurate their new IN>TIME performance series opening in partnership with the School of the Art Institute of Chicago and the Chicago Performance Network in October 2007. I was serving at SAIC as one of their first two Distinguished Fellows in Interdisciplinary Art Practice through their Graduate Sculpture Department, along with landscape architect Walter Hood, writing, lecturing and giving graduate studio critiques. I was also, however, seeking to create a collective piece in the public sphere as the culmination of that process, so the commission was timely.

The Chicago Cultural Center was designed to be the city's first permanent structure of its public library system: a grand civic space built in the classical revival style. The Rotunda was constructed as a memorial to the Grand Army of the Republic by the Association of Union Veterans from the American Civil War. Its beautiful stained-glass dome has an intricate Renaissance pattern. Its walls are of pink marble from Tennessee, lined with identical tall wooden doors crowned with war emblems and text. Its mosaic floor has nine grids of translucent glass blocks through which suffused vertical beams of light emanate from below.

Whenever I visit a new place, I enter it openly, surrendering to its messages not just through its landscape and people, but also through its architecture as the embodiment of their beliefs. When

performance artist Trevor Martin accompanied me to the Center for the first time one early winter morning, upon climbing the staircase to a second floor where all vertical lines made me look up through a Romanesque arch, I was struck by the word *MEMORIAL* embedded high upon the Rotunda's walls. It immediately felt like the inescapable title of the new piece. Looking down at the mosaic floor, once again following the architecture's lead, with nine embedded rectangles of light measuring 55 by 77 inches, 138 inches apart on all four sides, I felt as if I were before a great chessboard for a group of performers as chess pieces. I immediately envisioned the group wearing white, moving in and out of light and shadows, mourning, manifesting *absence through presence.*

I had been dreaming of forming a sustainable association of performers scattered throughout the country that could be selectively activated based on project location, scheduling, content and funding. Suddenly, the Rotunda's floor design materialized the first edition of the group.

The Rotunda offered an intuitive site for a *living memorial,* for reactivating memorial architecture through a group of performers engaging it through *a geometry of loss* choreographed by pain. Its floor design struck me as a labyrinth, providing bodies with emotional nonroutes through a potentially archetypal, unspoken narrative of mourning. And they would be moved—bodies moving with no particular destination other than reclaiming deep emotions, interiority. They would be humble and humbling bodies walking nowhere. They would be of no importance, like movable institutional furniture, like revolving doors, simply following the life of a building, in tune with it. But they would also be the most important bodies in America during one sacred day, because they would reclaim and embody its dwindling morality.

Thus, from the first conversation I had with performance artist and curator Sara Schnadt, and director and producer Claire Sutton, I began to transform what was initially an invitation to perform solo into an opportunity for a group. It was a huge risk for all. My vision of the group opportunity was not only challenged by the fact

that there was only a budget for one performer, but I also worked with the conviction that the process of developing the piece should unfold as a school. This shocked some of my peers, who feared that I might risk the quality of the performance because of the added burden of educating while training and training while educating. Yet, that is what I have always done. I was finally claiming it and turning it into a documented structure.

There are crossroads where one must risk failure, real professional failure, in order to break through a barrier and achieve the unimaginable. So I held on to the conviction that the process leading up to the piece, and the enactment of the piece itself, should be a vessel that recruited, educated, trained and ultimately showcased both graduate art students and local artists. Over time my notion of a performance project as a school has evolved from a very simple behind-the-scenes mentoring gesture to a more ambitious structure.

I am always trying to envision how to open up the creative process. The creation of a new piece can become an ephemeral school for training a new generation, as well as a means to collaborate with local artists, dispelling resentment against a perceived celebrity artist invasion and hierarchical dismissal, grounding the piece even more deeply as local artists realize that it belongs to them too.

Performance practice is about experience, not mirage. In the case of what came to be known as *Memorial Gestures: Mourning and Yearning at the Rotunda of the Grand Army of the Republic*, I designed a three-day training based on the notion of publicly performing enlightenment. I would lead a combination of performance workshop and meditation retreat. I eventually returned to Chicago seeking to experiment with an alternative kind of artistic leadership, closer to what participants may experience in ashrams and sanghas, even as I wanted to avoid the cult of personality.

The best way I know to elicit participants' vulnerability is through my own personal and professional revelations before them. Vulnerability elicits ability. This is not a seductive psychological

striptease, but an act of self-less if not self-sacrificing generosity far deeper than mere professional transparency. One cannot choreograph trust. One must stand ready to reveal aspects of one's personal past and present during such an ambitious process, so as to create an environment of old and new revelations that open the minds, hearts and bodies of the performers.

I shared with my group, then a bunch of eager strangers. There had been no individual interviews or portfolio reviews, but only an open call. I spoke about some of my own experiences of deprivation, starting with my family's loss of everything as a result of communism. I humorously shared with them the difference between carrying emotional baggage and emotional luggage—how we are burdened victims unable to control the first, but empowered travelers in control of the second. And I carefully invited the performers to harvest from deep within. And if they did not have such personal histories, as certainly not everyone is marked by tragedy, I instructed them to generously come out of themselves and empathically borrow the tragedies of others in emotional solidarity.

Our performance began at 1:00 p.m. on Saturday, October 6, in a classroom at SAIC, three days before the performance was staged. The first thing I expressed to the participants was that the performance began in that room. At that moment, I was performing for them, they for me and each other, and we all for an invisible but already very present public. I asked our participants to close their eyes and let go of the events of the past week, of the already-stressful new semester, letting all anxiety fall away in order to be fully present. I presented them with the late nineteenth-century life of Thérèse Martin through portraits taken by Celine, her photographer sister who had joined the same French Carmelite cloister. We looked at the Western European notion of hidden holiness that culminates in a very public sanctity, as constructed by a devout performer and documented by her loyal photographer. Those remarkable performative images, an important though forgotten trove of the early history of photography, were part of the visual landscape of Roman Catholic Christians until the middle of the twentieth century, their silent poses and gestures widely

imitated both in modern religious photography and life.

Memorials say as much about survivors as about the dead. Ultimately, they are monuments to the mourners, who also die. Thus, they memorialize twice. And if subsequent generations maintain them, they memorialize thrice; they memorialize morality.

The Rotunda was built by Christians to honor their dead and embody their mourning, forever memorializing and materializing the absences they suffered. It is a dignified monument to heroic absence and unbearable grief. But all mourning over war was unpatriotic in 2007, a politically conservative time in America when everything that approached a critique of our armed conflict in the Middle East was perversely manipulated as a form of betrayal. Nevertheless, being a believer in metaphor, I thought that if we could poetically perform a contemporary living memorial to loss through the excuse of the Civil War, performing that long-gone generation, our gentle conjuring might begin to approach and invoke the now. Performance is sometimes about the casting of spells. The audience enters one time period but slowly finds itself safely transported to another.

We only had twelve hours to workshop a twelve-hour performance. We spent the first workshop talking about whether it was possible to perform enlightenment. We walked conceptually right into the heart of the performance; and then, following my lecture, which established a reflective mood, we did a quick costume check of everyone's whites. The participants thus got to visualize themselves as a uniformed (and uniform) performance group. Some of the costumes were replaced, partly or fully, by items I brought with me. All who received these items were told that they could keep them as gifts. Everyone felt totally trusted long before they had earned it. Finally, we read and discussed an updated draft of the original performance proposal document. I wanted to close the first four-hour training session with what compels me about America's moral crisis, and lock them in that place overnight. If I succeeded, all else would follow. We spent the second day learning how to walk. I dressed in white, in one of the unisex costumes most were going to wear (I would

ultimately wear a robe) and showed them a combined monk-and-dancer step I have slowly developed and adapted to various circumstances. Slow, self-conscious walking is hard for a busy mind and for a body used to speed. One can stumble and fall very easily from the height of one's own distracted mind and light steps. So we performed combinations: we walked singly, in pairs holding hands and together as a wall. I walked with each performer, and they tried to follow my slow, conscious step. Each one adapted my step to what their height, weight, bone structure, spinal alignment and emotional state allowed. We marked the floor with tape and began to enact the performance as if we were in the Rotunda. We followed a simple mathematical equation that would trigger movement, from one to sixteen, like a domino effect, so that the movement of the first mourner provoked the movement of everyone else in sequence, or in parallel. Everyone went home that evening with the assignment to walk slowly and mindfully around their house in the dark.

I started with the idea of six core performers (a multiple of three, to fill two-thirds of the nine rectangles of light, always leaving three absences), supported by an indeterminate number of stand-ins who would fill in for the six core performers, who needed to take breaks to use the nearby public toilets, make phone calls, eat, nap or just lie down to rest their sore backs. Initially, the stand-ins were conceived as hidden from view and would only appear when one of the core performers decided to take an absence, exiting through the central back door. Stand-ins would be sitting in a green room, a lounge created for our private use, ready to replace us throughout the day.

When I shared that setup with friends, however, they challenged my hiding them and suggested that they sit around openly, mixed in with the public. I initially found that alternative confusing for the public. But the more I pondered it, the more it began to fulfill my notion of the performance as a school, and as audience-participatory. As performers sat arm in arm, shoulder to shoulder with the audience, they would have an impact on the bodies of the public very directly with their boundariless immediacy, literally reshaping them. The audience would inevitably imitate them, the

way we all end up sitting similarly in a waiting room. The body's posture is contagious; the body is viral.

Over time, the performance became about alternating *Standing Mourners* and *Sitting Mourners*, with no staged hierarchy between them. The standing mourners visibly generated silence, while the sitting ones sat among the public protecting but also expanding the cloister wall of that silence (the rings of a pebble dropped in a pond), as well as blurring the boundary between performers and audience, between performance and real life. The sitting performers would definitely model behavior to the public, as they would sit contained, in perfect silence. The performance was all about the containment and slow release of grief, and I needed an equally contained slowed-down audience.

To mitigate the strain on the body, give a sense of the passage of time in a windowless room and have enough time to exemplify an extensive but subtle inventory of mourning gestures, I devised a time-marking method using an 1860s school bell borrowed from a private collection. The bell rested on a wooden pedestal of the same period. Monastic life is marked by the sound of small and large bells. Our bell would be rung by four successive bell ringers in three-hour shifts, every fifteen minutes for twelve hours. Every time it rang, the standing mourners had the option to drop their gestures and, one by one, change positions without touching each other, signaling with their gaze and body the direction in which they were moving. The sitting mourners would wait until the standing mourners had almost finished to begin to move around the room, from chair to floor, and vice versa.

When standing mourners needed to take absences, they would wait until all group movement had stopped, then walk away from their rectangle of light, visually select a sitting mourner, slowly approach them and gesture to them with their hand, without touching. No touch was allowed throughout the twelve hours. We related to each other as if through veils. The sitting mourner would get up and follow the standing mourner to a rectangle of light, where he or she would take the standing mourner's place for up to an hour. I called

this transmission of responsibility *The Inheritance*. Everyone got to sit and stand.

On Monday morning, October 8, the day before the performance, we finally got our one chance to check the choreography in the Rotunda. We had four hours. The building was closed because of Columbus Day, so we had it to ourselves. Claire and Sara had stripped the space as I had requested, but a series of wall lamps were still lit, so the performers were not yet able to experience the full darkness I envisioned. Still, we were in costume, and everyone was seduced by the spectral look of the piece, whether standing or sitting. Everyone got to see each other in light and shadow, experiencing the cold (but thankfully not frigid) mosaic floor, the warm comforting lights beneath their feet when standing on the nine rectangles, the dramatically strong sound and haunting echo of the wooden doors as they opened and closed—all that was sensory about the piece and that had had to wait until then. I had worked on their minds, bodies and hearts, but the room now picked them up and took them to its own secret places.

Documentarian Peter Coombs, our photographer and videographer, came for an hour to shoot what I considered the more invasive press and archival images, closeups of faces and hands, to spare the piece and the public from real-time distractions. Peter would return the next day, for a second hour, to briefly video the live piece from a distance, discreetly seeking the public's reaction. Nevertheless, even during this third and last workshop, the group never had time to stand in place for the full fifteen minutes that divided the twelve hours into physically manageable segments. We walked through an abbreviated version of the piece, simply checking postures, gestures, walks and exchanges in place. In one way, it was a huge risk, but in another it was a great blessing because, so far, I have always avoided formally rehearsing anything. The unknown is a trusted part of my signature.

Thus, the performers never experienced more than five minutes of preperforming formal standing in place. I kept speaking to them of sinking into silence, of the layers of silence: in terms of a

first layer into which mind and body adjust themselves without feeling threatened; of a second deeper layer into which the self goes dormant as the mind empties willingly to some extent; and of a third more indefinable depth in which, if there is no reactive panic attack, the self is lost, the mind is totally quiet and the performer may have difficulty returning from.

Much was said, even as much was left unsaid. Some important things must remain unsaid; the performers must find them out for themselves. That was the point of the bell: to give permission for the psyche to wander about safely, then to call it back in case it got lost as the silence deepened over twelve hours. The performers dove deeper into an ocean, far beyond the self, into the collective, into nothingness. Even as the group walked into the durational performance without having fully experienced all the required training for such a demanding piece, I had every confidence that they were caught in it, unconsciously, intellectually, emotionally and physically.

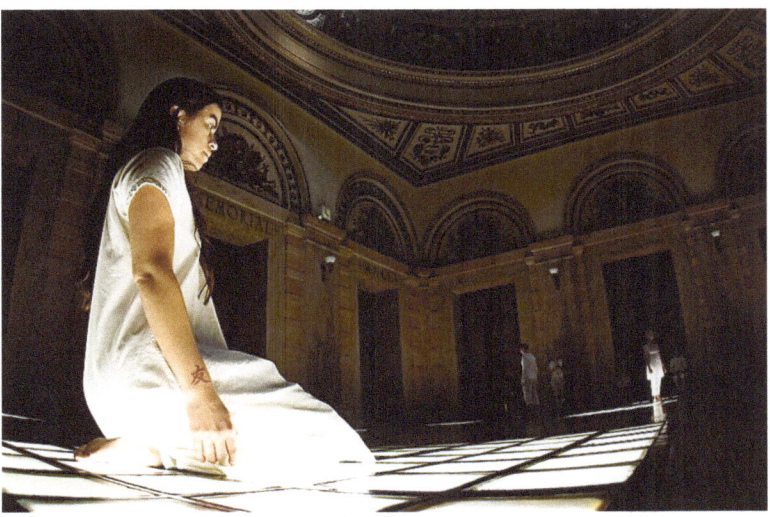

Memorial Gestures performance (Carla Duarte pictured), digital image by Peter Coombs, Chicago, 2007

Once the performance finally began on the morning of Tuesday, October 9, at 10:00 a.m., the passage of time began to manifest itself as segmented, contained, slowed and even dissolved in various ways. There was time as a fact of nature, because even though the Rotunda does not have windows, its dome lets in a certain amount of filtered natural light throughout the day, acting like a golden sundial moving around until it vanishes with darkness. There was time as a construct of civilization, in terms of the sound of a school bell rung by human hands every fifteen minutes throughout the twelve hours. Finally, there were human bodies, with their biorhythms, time markers unto themselves, with the need to breathe, eat, urinate, evacuate, rest and sleep.

The performance began to reveal how time is an incredibly elastic construct. As the performers stood still, walked and gestured slowly for twelve hours, their silence became an entity that heightened not just their own but everyone else's awareness, slowing down everything and everyone, filling and sensorially expanding the dimensions of the room: its height, depth and width. The silence emptied the room of noise; it rejected noise (a noontime jazz concert on the floor below leaked up, but our silence neutralized it), filling the room with itself, as tangible as liquid, as if the room was a water tank. Silence did not create a void; it had a tangible body we could cut through with a knife.

Psychic space is vast, like an unfenced prairie running in every direction. That has been my own ongoing experience of the healing effects of silence, first encountered during my monastic experience. I always go back to a world of silence after teaching, traveling, lecturing and performing. It is my healing refuge. That opening of an internal psychic vista is what silence does to postulants and novices as they enter a monastery, but is sadly lost from urban life and contemporary art education. In Chicago, I created the occasion for it to be experienced briefly. Indeed, I find that much of my performance work is about reintroducing this deep silence, creating roads back to silence.

Later, the performers spoke of how their friends and family enjoyed

the silence and realized how much they craved it in their daily lives. Most Westerners stopped experiencing silence in public spaces since church and synagogue attendance dropped, since the Internet replaced library visits, and since museums became malls. Our Chicago public unexpectedly found silence again, a silence that human beings need to sustain the human condition: for listening, remembering, reflecting, discerning, deciding, healing and evolving. Silence is a human right.

On the surface, the audience experienced slowness; under the surface, the performers experienced the faster flow of a river. I did not notice much of what was going on around us, however, although occasionally I recognized people at the edge of my sight. If the audience grew noisy, my body would make a point of kneeling by the main entrance arch to the Rotunda, creating a boundary that wordlessly signaled a return to silence. My body shielded our silence. I did not plan that; it did it on its own, moving to where it felt the most vibrations. My body was like a big ear.

Throughout the day, I stood, walked, gestured, paused, walked again and knelt for longer periods toward the end, as my back began to hurt, as my legs fell asleep and it became increasingly hard to rise at the next sound of the bell. I had planned to unleash on myself a whole flood of sad memories from a recent personally devastating loss, but the performance refused it. The performance had a life of its own, and it refused my sadness, or perhaps swallowed it instantly, within the first two hours, so that my mind was left blank, as during Zen Buddhist meditation against a wall in a zendo. I felt so proud of my young performers, of the ephemeral school that had successfully been created around the performance.

My eyes began to follow the performers and to make connections between us, and between us and the architecture. I felt as if my eyes could draw visible lines. I would look up and notice out of the corner of my eye that people looked up with me, seeking the far point of my gaze, or followed my gaze across the room to another body. Indeed, people mimicked us throughout the day, taking off their shoes to experience the cold floor with us,

almost embarrassingly imitating our gestures, even walking away in step with us and then suddenly turning around and bowing to the performance before exiting it. That action initially caught me by surprise and disturbed me. (I didn't want to generate the muscle memory of submission to institutionalized religion in the audience.) Psychologically, I knew that it would be extremely hard to extricate ourselves from an ongoing piece that had grabbed and anchored us. But afterward, viewers explained to me that they were compelled to do so as an acknowledgement of the silence, stillness and absence evoked by the piece, bowing to something sacred.

One of the most remarkable things that happened during the performance was its pliability as a template, already foreshadowed as the performers added additional mourning gestures to the inventory I initially provided them. During the performance, this enriched template reached its peak fluidity, as all the performers, dwelling in the moment, began to improvise unforeseen movements walking around and across the room, clockwise and counterclockwise. The four bell ringers in particular, who had been asked to stand still for three hours in the same spot by a column, began to perambulate the room, as if they were the hands of a colossal invisible clock, marking time not only with their rings, but with their need to move out of stasis.

Sometimes all the standing and sitting mourners would stand and move at the same time, creating multiple parallelisms that seemed complexly choreographed to the onlooker, who must have wandered how we did it. This pliability was one of the greatest achievements of the piece, technically and emotionally, because it was the product of trusting moments. During the last moments of the performance, the sitting mourners began to exit at 9:30 p.m., so that the standing mourners would be left alone in the center of the space, still holding it in spite of their twelve-hour exhaustion. Such an act was a concession to the classicism of durational performance art, because during a long piece many people come to see its beginning and end, almost as if to verify the evidence of the passage of time on the body of its performers. It is a brutal test and a beautiful thing.

Unbeknownst to the audience, our sitting mourners ran back to our green room as they exited, changed quickly out of their whites and joined our colorful public to watch the end of the performance. I saw them and was very moved. The bell began to ring for one last time at 10:00 p.m., and the standing mourners became poised for their exit. The bell first rang four times, allowing the vibrations emanating from every ring to fully dissipate each time. Then, it began its last six rings even more slowly, a sound sequence that would lead up to closure. The sixth mourner stepped out of his pool of light, walked slowly to the back of the room, opened the central door and disappeared, allowing for its creaking and banging sound to resonate. One by one the audience began to lose the five remaining standing performers as the bell approached its tenth ring. It was the beginning of a new level of absence, more current. We had lost a generation of men and women to the Civil War, to all American wars, but now we were also losing the generations that remembered them, if not our historical memory, our consciousness, and we were caught tragically repeating the same mistakes, seemingly forever.

When the tenth bell rang, Carla Duarte, our last bell ringer, put down her instrument and exited. I was left alone, with no one to ring a bell for me, for my psychic death. At that point, even though I thought of the bodhisattva tradition in which an individual takes a community to nirvana but remains outside and walks back to seek another group to bring, I felt profoundly alone; I felt great pain. The audience at the other side of the room felt a million miles away. The absence of my performers, symbolizing our war dead, had become a very real absence in my heart. I experienced real loss. I was confronted with my solitude, with my loneliness as an American, a man, an artist, a lover, and I almost began to cry. But just as I fell deeper and deeper inside the void created by that absence, I somehow grabbed and held those thoughts and emotions out of the air with an invisibly extended left hand, like one holding a tornado by the thread of its base. I lifted my robe with my right hand, so as not to stumble and took a few steps away from the rectangle of light I had been standing on and walked into the shadows, into the mosaic path through the floor grid.

As I have done in other performances, I had saved the most painful memories of my recent past for this final moment, when I would need to be most vulnerable. Nevertheless, I found myself not having to make use of them because absence had become real. In addition, I had held on to the day knowing that this might be one of those moments in one's practice that may never be surpassed, and that it was about to be over forever. We had created a landscape of mourning, of absence through presence, still intact in the room, even as it was also dissolving fast. So I made the split-second choice of holding on to it for a little longer and began to walk a circle in the room, a circle inside a square, gazing at the empty grids of light, one by one, recalling the performers' faces, bodies and gestures, calling their names within me. And time began to further slow down and expand. The room began to get wider, deeper, taller. Time slowed down to a halt, and the room began to merge with the universe. My tired feet dragged, but this motion connected with the trailing white robe, made in Kuwait by an Arab tailor; my body gave the impression both of floating and wiping the floor clean, like a final ritual cleansing. I was walking counterclockwise, within time but also against time, slowing and halting its flow.

Because the public was with me, looking, following, walking and feeling with me, trying to see what I was seeing, but also sitting at the opposite end of the space, what seemed like an invisible energetic band began to manifest itself and stretch between us, each pole holding to an end. Performer Kate Lindholm vividly described it later as being bound together by a rubber band that began to stretch from one end of the room to the other. By the time I reached the central back door, the band had stretched to its breaking point, and we were all on the edge of an abyss of timelessness. We were all suspended in a timeless moment in time.

I began to turn within the turn. My gaze ascended the walls toward the dome, to sadly regard it for the last time. My gaze descended back to the audience, to regard them across a dark distance. My head bounced in slow motion, up and down, from left to right and back. I finished the turn with my back to the audience, psychically exhausted but determined, mourning the end of mourning. I began

to turn the brass knob, slowly opening the door, inserting my body across its slit, entering the other side, sweeping up and scooping my robe's train away from its closing. Then suddenly I closed the door, and the energetic band broke. It snapped and flew back and forth, lashing, hitting me and the audience with a silent bang masked by the echo of the door. The space rang as if totally empty; the space felt completely emptied forever. The absence was total. People woke up in shock as if from a spell. No one knew what had just happened. There was applause.

I turned around inside, coming back from the absence, returning from redemption, and the five standing mourners who had also changed and joined the audience to witness the end of our piece came back into the green room and stood in line in the dark, looking like men and women still in the hold of a dream, a bit hypnotized, a bit paralyzed. Somewhat dehydrated, I opened my parched lips and said *that was the passage of time*. And they too woke up and rushed to hug me, as the sitting mourners also began to file in and hug each other while I could still sense the room outside increasingly emptying of what remained of the audience. It was going back to being just an empty old room, and that was very sad.

Thinking back on those last moments, although I created a performance group and hid within it during the performance, I still needed to give closure to the piece. It was a question of both artistic experience and pedagogical leadership, the way a dancer like Mark Morris unapologetically used to sign a piece with his large hairy body in the midst of his dance corps, without taking anything away from it. I always thought that he added to their power, body-complementing and body-contrasting. Our young performers, still graduate students, had never performed such rigorous gestural containment or sustained that much silence. Therefore, it was my sense that they were not ready yet to give closure to the piece, so I took on this responsibility.

A dramatic group exit does not necessarily result in psychic closure to anything. There is no performance strength in mere numbers.

This is not ballet. I had knowingly challenged and placed the group in a position far more psychically advanced than they were at the time. They generously trusted my direction, walked and inhabited silence, stillness and mourning, generating absence. I remained, however, carrying the ultimate responsibility of closing that archetypal portal, that mythical door of hope, memory, dream and nightmare.

After it was over, we all went our separate ways, and I walked down a cold, empty avenue to the school-dorm apartment I was using. It had a partial view of downtown Chicago. I stood alone in the dark, suddenly hungry, and knelt in front of the window facing the city in gratitude for that long day. I fell asleep with an empty stomach, but with my clothes on. I returned to the Rotunda early the next morning to say goodbye to the room, now filled with activity, and my body immediately slowed its step, following the floor pattern, walking in and out of the lights, the choreography still embedded in me, so that I had to force myself out of it. My mind had to order my body to walk away; it was one of the few occasions when it has had such precedence over it. It suddenly dawned on me that morning that I had to recruit the others into doing what I always do for myself, this ritual of completion. I had to complete the lesson for my performers, for my school. Therefore, later that morning I took the performers back to bid their own goodbyes to the site. I explained to them how they now had a secret relationship with the site. They walked around it and had reactions similar to mine.

Later that afternoon, we spoke in a panel hosted by curator Mary Jane Jacob as part of her graduate sculpture seminar. There was not much to say, as most of the students had witnessed the piece. There were only a few technical questions. I returned to New York late that evening with performer Joy Whalen, whom I had brought over as part of my team. I then taught the next day from 9:00 a.m. to 8:30 p.m. I felt as if I had stumbled back from a distant dimension but that no one knew about my experiences there.

E-mail Responses

A photographer who spent time with us in the Rotunda, next to whom I knelt for a while, wrote, *I could see your robe pulsing at the same beat as your heart; a transfer of energy, from you to your clothing, to the molecules in the air, to the senses of the audience. I started tearing. I became very saddened. I felt my own sorrow and felt yours. Perhaps the performance allowed for the "sharing" of sadness? If one person has more sorrow than the next, the burden can be shared, evenly distributed, throughout a community of mourners.*

A graduate student wrote, *It's shocking how little public space is given to mourning given so many of our global situations, and your piece brought that into very clear focus. Also, while it was evident that the performers were mourning, I felt mournful only occasionally in the space, for it was understood in a sense that you were mourning in a public way on my (or the audience's) behalf. I couldn't believe when I read there was fifteen minutes between chimes. It seemed like they were much closer together. Time really took on a very different quality. In fact, many of my impressions were really focused on how radical the passage of time was compared to the way it flowed just outside the space before entering and after leaving.*

Professor Trevor Martin, who generously served as project recruiter, and without whom the group would never have formed, wrote extensively and eloquently about his experience of the piece, sharing it with everyone over a series of e-mails:

I cried throughout the day while in the space. It was a deep, general sadness. I kept trying to peg it on something specific, but it was more than this. It was a quiet, hard feeling that registered our temporality, our ephemeral nature as beings. Perhaps it was the distance from those I love, living many miles away, and how no matter how hard I work to assist and cultivate others' work, it is understood by many as only a job. Perhaps it was the difficulty that our students face in negotiating the world, and the fact that they wrestle so much with poverty and misunderstanding; or their struggles as individuals to find themselves amid chaos, war and an uncertain future. Perhaps it was the release

of general stress. Which is to say, this sadness was not one thing, it was many things. I felt it most poignantly when I looked across and saw the students standing in silence, a vigil. We were standing and taking turns in a vigil for those lost, or a loss in general, across time, caring for each other as we did it and caring for each other so fervently, serving as the safety net for each other in this commitment to be present, to just be present, silent and still, for all that is absent... To bear witness and bear company to this absence.

Admittedly, it was a beautiful and wonderfully hard day, a long day. It was hard on the body, we all know this, and we learned much from the labor of the work and it felt, appropriately, like "work." We learned the limits of the body and how to negotiate such limits. And the learning was a gift as well. The holistic performative experience really began, as you said, on Saturday. I was amazed at how dedicated the students were. They skipped classes, even though they planned to be there for just a couple of hours, because they didn't want to miss the experience; they didn't want to absent themselves from the performative vessel of knowing, seeing, feeling, learning. This is so rare, to see such commitment, to give so freely, so many hours of one's life.

This has been a remarkable encounter with time itself, with memory, with site, with the creative potential of stillness and silence. I don't think I've ever encountered twelve hours with such clarity before. Or should I say it was 720 minutes? Or 43,200 seconds? Or the endless milliseconds in-between that were registered in our bodies, in our hearts and minds? It was twelve hours of rehearsal and twelve hours of performance. Amazing how 86,400 seconds can speak to one's life in potentially deep and significant ways. It makes me understand the additional seconds, the other seconds, in these days that have followed, with different eyes, with a different heart. I recognize that it is really time that moves us slowly away from last Tuesday's experience..., and it is time, fluid, and in many ways immeasurable, that moves us away from our past experiences of grief, of loss, of trauma, of crisis, and yes, of joy, of peace, of happiness. Time is that tricky substance, defying capture, which moves and moves and moves.... It was good to be still against such motion, to be witness to each other amidst the motion. And, curiously, in the time to come, I wonder if I will hear a bell in the same way....

Students found it hard to return to regular classes after the performance and had to take some time off. I encouraged them to begin their mindful art practice at school, not after graduation; to take control of their education and have school be the laboratory where such a practice actually begins. Part of the group met a week later at the home of performers Paul and Kate Lindholm, where Carla Duarte performed a closure exercise. She sat everyone in a circle and spoke about creating a oneness between practice and school. Kate later wrote that the performance gave her the ability to sit with someone's pain without losing herself and without trying to rescue them from it. Carla wrote that the experience made her regard all emotion, comforting and troubling, as a gift. *This weekend something shifted, my anxiety dissipated by staring at it for twelve hours. Instead, a sense of courage has come, and has opened the door to my work.* As an educator, I believe that young artists start their journey seeking to create meaningful artwork, and that it is up to us to protect and sustain that sincerity.

Post-Performance Random Thoughts *December 31, 2011*

Almost five years ago to the day I was commissioned to create this piece, I am driven to reflect on the nostalgia that currently permeates much contemporary American culture. Nostalgia is the longing for periods, places, lifestyles and possessions lost, seeking to reclaim them. Mourning, on the other hand, is the mature expression of deep emotion for what has been lost, bearing the knowledge that what has been lost is irrecoverable and thus irreplaceable. It allows the body to be convulsed by sorrow as a stage for letting go and moving on, for healing and growth. Nostalgia is a more adolescent gesture, seeking to replace what has been lost out of an unwillingness to let go, sometimes out of fear of the future, recycling for lack of a future. Nostalgia can be the gesture of those who are lost, while mourning is the gesture of those who seek a future.

Toward the end of my twelve hours performing *Memorial Gestures*, I lost my sense of time, even as there was a bell marking time. When the bell rang 10:00 p.m., I had been left alone holding the

space, and it was my turn to leave. The actual passage of time began to come to a standstill for me. I started my walk around the empty space, dragging my feet as if they were pulling boulders. I was outside of time watching people in time, through a veil. I inhabited a timeless reality, watching the public across the room inhabit a time-bound reality. We were years away from each other even as we were also only feet away. I finally stood still, looking at the space. It felt vast, as if it contained the entire universe. It was otherworldly. It was material and immaterial. I suddenly realized that we had created a portal into another dimension. But I could not go on to inhabit it. I had to return to this dimension. So I looked up at the dome, which felt as high as the heavens, and as much as my spirit wanted to rise, I took a deep breath and began to turn. And the second I did, time began to rush back into the room, into the void around me.

Time began to rush back almost perceptibly, as if it was wind or water. I could see time, the gauzy waves of time, rushing in as if through a funnel, a vortex that was aiming to touch ground at my body's point. And so it did. The experience ran from timelessness to time-sitedness in a flash. I was almost hit by a gigantic wall. My body shook under the robe as it turned, almost thrown off balance. Yet I opened the door and left. That is what I still remember.

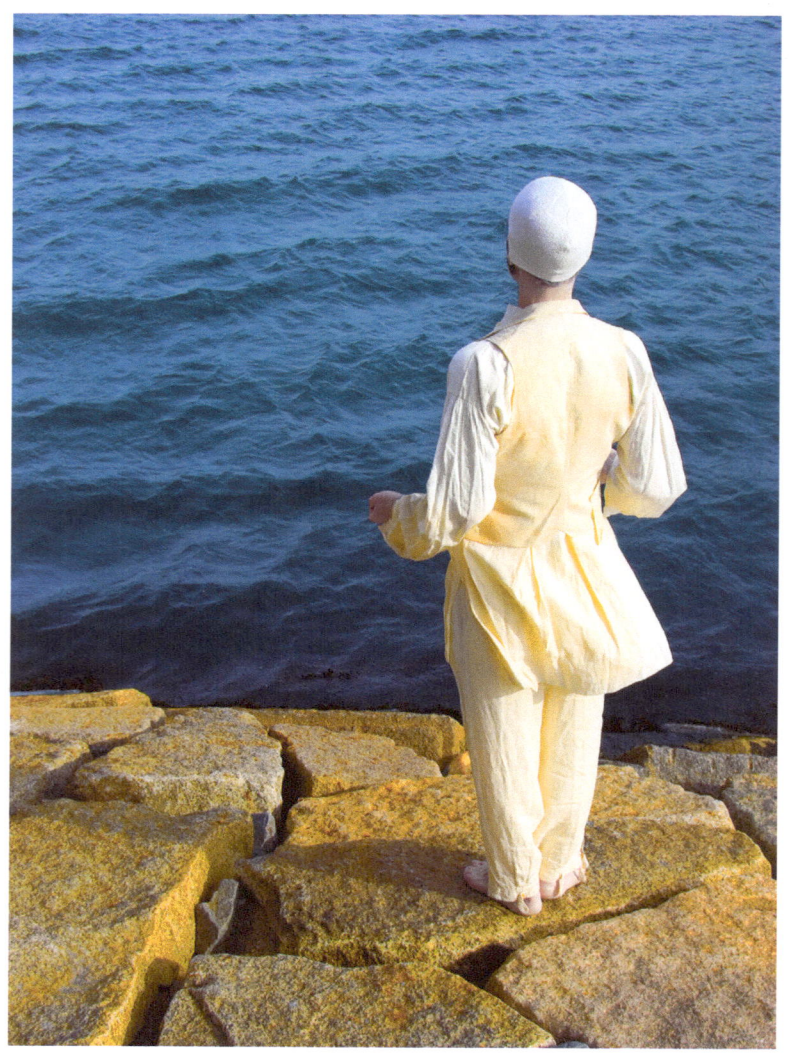
Water Cycle performance, digital image, Boston Harbor, 2007

All has been lost when a performer sets foot outside an institution. He is no longer on a pedestal; there is no height to fall from. He is nothing and less than nothing; he is shamelessly and completely free.

Chapter Six ***Walking on Water* [*Boston*]**

In 2006, curator Carole Anne Meehan invited me to submit a proposal to the Institute of Contemporary Art in Boston for a site-specific work for their new waterfront building designed by architects Diller Scofidio + Renfro. The performance was intended to explore the relationship between the people of Boston and the Atlantic Ocean.

I began to research nature's water cycle. Water is always in movement, above, below and across the earth's surface. The water cycle has no end and no beginning. Water can be ice, vapor or liquid during the cycle. The juice we squirt from a lime was rain last season somewhere around the globe. We swim in oceans fed by rivers and in rivers rained on by clouds fed by oceans.

Zen Buddhist tradition envisions the bodhisattva as an individual who sells water by the river. But you might ask: why sell water by a river when everyone can get it for free from that river? A wise teacher will answer that few see the water, so the bodhisattva must behave like a clown, like the village idiot, performing a foolish gesture. He must generate a respectful tension, a healthy discomfort. There would be no need to sell water by a river if people psychically saw that great river. And what if everyone also realized that the water we drink and fish from is poisoned, polluted? How would they purify such an immensity of water at a time when bodies feel so disempowered? My performance thus began to be planned as a journey to an aqueous revelation: the remembrance of deep waters. American popular culture lacks depth. Could I perform a poetic process about the yearning for depth, about seeking our depths?

Ultimately, between my many visits to Boston Harbor, reading Herman Melville's tragic *Billy Bud, Sailor,* and my perusal through images of many water carriers, such as *The Waterseller of Seville* by Diego Velázquez, I conceived of an *aguador*, a water bearer who would carry multiple, hand-blown glass vessels to gather water from selected harbor sites. On a series of bright sunny mornings on summer weekends, he would be found by viewers within the ICA, like a pale ghost who appears through a white wall, later walking silently along the city's crowded waterfront. He would be a walker, but he would also have the capacity to remain very still for long periods of time, eyes slightly closed in contemplation, while waiting for a boat to cross the harbor.

I saw the waterman riding the harbor's commuter ferry system to various islands and walking their perimeter, drawing their shapes one step at a time with his body. He would stop as he finished his perambulation and walk down to the beach of his choice to gather water with a vessel he carried in a pouch. Each water pilgrimage would require a unique glass vessel, hand-blown in the shape of the island visited. He would perform all this unhurried, above and beyond any concern for time. Each pilgrimage would last whatever time it needed. Thus, each would also be an adventure. The water carrier would bend or kneel, scoop water from the surf, cork his vial, finish his perambulation, go back to the island's dock and remain perfectly still at some lookout point, waiting for a boat to return to the mainland. He would then walk back to the ICA and deposit the water vessel on a table in the form of a wooden barrel with a stainless-steel top, loosely engraved with the map of the harbor, as a water sculpture.

I would have loved to engage the harbor's thirty-four islands during a thirty-four month period. That is the kind of performance cycle we need in crafting an alternative performance tradition. But this was beyond our nonprofit budget, so we selected five islands. Nevertheless, I wish that a cultural institution partnered with a city and committed to such a long-term performance project, allowing it to grow over time, slowly gathering attention by word of mouth, as it humbly integrated itself into the seasonal life of a site or a network of

sites over one or more years, becoming a school, an ongoing reflection of place.

I kept thinking of Felix Gonzalez-Torres's words during one of his last interviews, in which he expressed how much he needed his viewer's interaction. Without it, his work was nothing. He joked that he thought of himself as a theater director. My five performances would be advertised through the ICA's printed literature and website, and members would be encouraged to RSVP if they wished to begin the early morning journey with me in the fourth-floor gallery, although everyone was welcomed to join along the way. The institution wanted to nurture a performance-cycle core of followers seeking and committing to a series of immersive experiences, rather than an unpredictable pied piper's haphazard entourage, though that was acceptable and important too. The program aimed to recruit more people along the way.

Because my five five-hour pilgrimages were in silence, many supporters, participants and accidental witnesses wondered what my mind was thinking and my body was experiencing during these journeys, which often had the quality of a trial, although my work has never been primarily about endurance. I thus asked the ICA's Mediatheque to create a blog that would allow me to communicate with my audiences, while maintaining my silence throughout the walks. I posted entries leading up to each walk, and right after. Readers followed avidly, rushing to read what had been going through my head and what my body experienced during each walk.

Early November 2006

In her recent bestselling history of walking, a must-read for all performance artists, Rebecca Solnit speaks about the soil of the sacred, in terms of its manifestation as a *spiritual geography* across which the human body consistently performs the soul. In her 1990s tale of pilgrims on the road to Santiago de Compostela, Nancy Louise Frey writes that pilgrims develop a different sense of time; their senses heighten. She believes that they develop a new awareness of their bodies. The landscape deepens because their sight

gets sharper; thus, they walk more conscious of their steps and their effect on themselves and the road.

The Medieval Christian literature of pilgrimage to sacred sites states that most revelation and transformation happen along the journey, not at arrival. Arrival is but a confirmation of what has been experienced along the way. The way strips, the pilgrim sheds, and arrival is no more than a moment of recognition that all has changed—that one is no longer the same person who set out. In fact, arrival can be anticlimactic, even disappointing, making the journey all the more important. Perhaps the destination is smaller and plainer than anticipated, commercialized, cluttered, chaotic, crowded and stinky; or perhaps its premodern colonial opulence is alien and off-putting. In the end, what travelers remember and wish to reclaim is the process; the journey is what they hope to revisit one day, again.

November 14, 2006

I wake up at 5:00 a.m. in New York. It is cold and dark; my body feels suspended in my bedroom's stillness. But I am flying from La Guardia to Boston and must grab a car service to the airport. I prefer traveling to Boston by train along the coast because of the reading time it affords me. I also savor the sense of a slow arrival to a new place—the opportunity to physically understand how it is constructed, from its wooded and rural big feet and hands, through its suburban and industrial long limbs, to its city-torso, downtown heart (cold or passionate) and finally its large city-government head. I can sometimes see some of that from above, of course, but it remains physically incomprehensible because I do not have a bird's body to understand places through height and landing. My human body lags behind by plane, whereas all of me, all my senses arrive simultaneously by train. My flight to Boston, however, is thankfully pleasant because the airplane is almost empty and I can move freely within it; I can walk the skies to Boston. I also listen to the soundtrack of *Orlando*, the 1992 film with Tilda Swinton directed by Sally Potter based on the novel by Virginia Woolf. It is a magical film, and it has one of my favorite Jimmy Somerville gender-

ambiguous songs, *Coming*. It is the right song for this moment, as I try to create a timeless character.

Later…

Boston is unseasonably grey and balmy for this time of year. I take the airport shuttle to the marine terminal, where I board a water taxi across the inner bay to the Seaport World Trade Center. There is a surprisingly peaceful silence not even broken by seagulls. The water is calm, covered with a thick mist. There is no boundary between sea and sky. I am the sole passenger on the boat; together we magically float through a cloud of grey. I sit at the ship's bow, speechless.

Body walks on water. How fitting that I should cross these waters in such a manner while preparing this performance. Am I dreaming? Am I dead? I do have a coin. My ferryman, however, is not Charon. We are not crossing the Acheron River toward Hades. No Cerberus awaits us. The Acheron River was so foul that the gods forced to drink from it by Zeus lost their voices for nine long years. I, on the contrary, hope to drink from these waters and find a voice here. Yet, this is just the kind of project that requires a psychic tax, a partial death of the self in public, so this morning's metaphor is fitting.

We dock and my body jumps out and walks quickly through a much less pleasant asphalt sea of open parking lots. I am always amazed by how my animal body can have a speed of its own volition when it hates its surroundings and wills to move through ugliness long before my mind has fully processed the aesthetics, lurking threats and warnings. I am meeting Carole at the new ICA building that will open this December. Their still-unfinished space is a beehive of male-worker activity. I help Carole prepare some handouts for this morning's meeting with officials from the US Parks Service and the Island Alliance. They are the gatekeepers of the thirty-four islands in Boston Harbor, and we need their stamp of approval to proceed.

We walk to the nearby offices along the waterfront as the sun

is peeping through the thick cloudbank. Seagulls hover noisily, hunting for breakfast. We labor through the government building's tight security and take an elevator to a generic carpeted boardroom where a large but welcoming several matronly women rangers dressed in blues, browns and dark greens hear our presentations. They look like sunburned, wrinkled and rugged pioneer women. Their exposed skin is leathery red and gold. I am very impressed. They are incredibly protective of their islands, like mythological goddesses at the gates of secret gardens, capable of love and fury, appreciative and nurturing of any efforts toward bringing more attention to their fragile, vanishing natural environments. Carole Anne distributes packets and presents the overall project concept. I follow her with a presentation of my past performance projects.

What feels right for Boston is performing a gentle gesture that weaves itself through the Harbor Islands like a thin, faded white thread through an old blue quilt, like water flowing among mossy rocks. I titled it *The Water Cycle*. I contemplate embodying a solitary dockworker, partly constructed through performance art, contemporary dance, Butoh visuals and the historical-reenactment genre so popular throughout New England. He would not be a ghost, but he might look ghostly. He would be dressed in period garments: an ample cotton shirt, a very tailored double vest, a tight cap and linen knickers. He would walk barefoot, no matter the smooth or rough, slippery or burning flooring. He would journey for water and bring it back like a holy relic.

I am done talking. There is a moment of silence as I hold my breath and look intensely at them, not knowing what to expect. The rangers suddenly burst into applause. They respond enthusiastically to my proposal. In fact, they request that it also include a public journal. They wish to read the thoughts of the walker as the performances unfold. I am also very lucky to meet Dr. Sally Snowman during that same meeting, the keeper of Little Brewster Island and its working lighthouse. She tells me that she leads tours by appointment in period clothing. I ask her if we could collaborate, even perform together. She gives me a big, beaming, lighthouse-keeper smile and without missing a beat responds that in the old days the lighthouse

keeper invited a ship's captain for tea. Our exchange feels like contact improvisation. I ask her if she would invite the water carrier to tea? Can we stage a silent Victorian tea ceremony in public? Sally loves the idea.

The Sailor *January 2007*

Herman Melville describes an eighteenth-century sailor's clothing as consisting of a soiled white jumper and white duck trousers, enveloping the young man like a shroud, a second skin in which he will live and die, more of a place that he inhabits than a uniform. I am not going to wash my garments after each performance. I am going to let them accumulate sweat, sand, salt, rain and stains until they become the most wholesome document of my body's experience.

E-mail to the ICA's Education Dept. *February 5, 2007*

Dear Ena,
In preparation for a morning meeting with ICA educators this Wednesday, I would like to present, as our guiding principle, the notion that my performances will be a process of inquiry through silence, slow movement and ritual gesture, embracing the discomfort of informed not-knowing. I choose not to know my outcomes even as I am aware of my many options and their potential results. The performance is a solitary pilgrimage (the one we all make through life, whether we are conscious of this or not), even if publicly enacted. The performances are a site for encountering the deeper meaning of a place, its depths. This is about questions rather than answers, at all levels.

Our education effort should thus be about sustaining this not-knowing and, later, perhaps much later, begin to decode what truly happened, which may not be about what we saw, but about what we remember. Education is sometimes about patiently waiting for the formation of insight in the unconscious. This is not a spectacle (in fact, it is unspectacular), even as it may be marketed as a spectacle.

I wish that all marketing were in the hands of poets.

Thanks,
EP

A Conversation

On February 23, 2007, Brigham Fay of the ICA interviewed me for the summer 2007 edition of their members' magazine. It appeared under the title *Buddhism, Billy Budd & Boston Harbor: A Conversation with Ernesto Pujol.*

This is a version of the original interview:

Brigham Fay: You spent a number of years as a Roman Catholic monk before returning to art making. Please talk about how that experience, and spirituality in general, informed your approach to creating this work.

Ernesto Pujol: Regarding monasticism, the Harbor Islands evoke the ancient notion of long pilgrimages to sacred sites, like Jerusalem and Mecca, to seek blessings—to collect holy water. A pilgrimage is about the journey, not about the destination. Because traveling there is what cleanses, edits and purifies you, losing unnecessary baggage along the way.

From the point of view of environmentalism, as the spirituality of the future, I am in awe of the immensity of the Atlantic Ocean, confronting us just minutes from downtown Boston; its ferocity and depth barely contained. Once out of the inner harbor, there is no question of who is the stronger one, the titan.

BF: Tell me about the waterman, or *aguador*, the role you will play in these performances. What is the significance of the waterman's costume? Why is he silent?

EP: People speak about the looming oil crisis, but the true crisis of the future will be the lack of fresh drinking water. I connect

this to my interest in the history of the human body, in terms of performative physical labor, remembering the men and women who used to carry things publicly for us. Then, there is the act of walking, which, from the point of view of evolution, is one of the gestures that made us human. The postmodern body, however, lives in a world of interiors; technology keeps it inside. It does not move, even as it desires to be moved at many levels.

As for the costume, it engages in a familiar visual language used in the local reenactment of history. In addition, it uses Butoh white makeup to set a boundary, because I need to feel safe as I place my vulnerable body among hundreds of people. The presentation is a hybrid between classic theatrical costuming, a modern dancer's lightness and performance art.

The water carrier is a timeless walker who slows us down. He is a contemplative, so his journey is silent. He introduces contemplation into the distracted public sphere. I like to create a solitary intimacy in public as a memory of interiority.

BF: The Harbor Islands each have had very different histories. You will visit a number of the islands. How do you incorporate each island's individual story in your performance?

EP: I have researched the Harbor Islands, but much of this will be organic, stemming from the Buddhist concept of choosing not-knowing. Carole Anne Meehan and I are coordinating the performances with officials from the US Parks Service and the Island Alliance. In the end, each performance will have unpredictable components in real time, which will be as important as what we planned. The performance is a site for finding out about the deeper meaning of the place. We will find it out together, during the event, and as we remember it later, in the months to follow.

I currently plan to walk the perimeter of Spectacle Island, which has shifted so many times. I also plan to approach the battery of Lovells Island and visit the lighthouse of Little Brewster Island. I

will have tea with its lady keeper (who will receive me in period costume). I will roam through the fort at Georges Island. But there are rain, wind, tides, children, wildflowers, birds and butterflies. I may stop and point at something. There should be surprises for you and for me. I need to be transformed too.

For *The Water Cycle*, you have worked with glass blowers and a costume historian, while members of the public can also take part in the performance. What role do collaboration and participation play in your work?

EP: I am increasingly interested in collaboration, even as I am commissioned to do projects as a single signature. I like to generate creative partnerships through my projects, at all levels, such as with artist Blaine Anderson, who will be my videographer.

Public art should be generous, as the expression of the citizenship of the artist. If public artistic processes are to be held accountable, they must be transparent. I am still learning about collaboration as I practice. I learn a lot from my partners; sometimes their unexpected questions generate new ideas. The process must be fluid, constantly adaptable. I plan to post selected text fragments from the journal of the waterman in the ICA's new Mediatheque, so that visitors can read my thoughts leading up to the performance, during and after. I would like to generate a conversation with the people of Boston.

BF: You describe these journeys to collect water as pilgrimages. What kind of experience do you hope to provide the viewers who follow the performance?

EP: I would love for viewers to experience silence in public. The experience of being within a silent group, on a silent journey, is unique. In the end, what I do, in terms of gathering water in small glass vessels, will be extremely simple—anticlimactic. This is not about me, but about reclaiming public space as a place for quiet reflection, for nurturing interiority.

I am aware that some viewers will be bored after a while and decide to drop out from the long journey. This is not a spectacle. I do not expect people to follow me for hours. I recognize the endurance ritual here, but that is what adds character to the performance, generating respect. I expect people to self-select in and out, the way they channel surf. That is acceptable. You never come back with everyone you set out with. Nevertheless, they are not lost. We touched each other for a while.

Notes from a Glass Foundry Meeting

I met with the glass foundry last week. I am guiding them through the production of five hand-blown, clear-glass vessels, one for every site in which I am performing. Their staff of glass artisans responded sensitively, agreeing that the glass component to this puzzle needed to have its own dignity through a final self-standing sculptural presence. They confirmed what I have been ruminating all along. They agreed that the five glass vessels should be more than high props, as I gather water from the various sites. The vessels should also transcend the muscular scientist's sampling tool. Indeed, although the notion of creating water time capsules is attractive, I do not want to capture nature, robbing it of anything while also creating more fetishized clutter. The bottles should be performative sculptures. While the glass vessels can be markers, like materialized chapters that contain peak moments in the journeys, I also seek the ephemeral. Perhaps they should not be sealed, and the water should evaporate back into the atmosphere (returning to the water cycle), leaving a sandy residue. However, I am drawn to the notion of a single sculpture that presents the shades of water, even if ephemerally. All of this currently remains unresolved, but I am not worried. This is my voluntary not-knowing.

The glass vessels could float over a stainless-steel, map-like surface. In this way, they would capture the light of the sun, creating movement across the silvery surface, even miniature rainbows. I like this idea; I am drawn to anything that embodies fluidity. The bottles should rest on a barrel-like pedestal made by a carpenter or sculptor, like the small portable barrel with fresh water or wine that

a sailor may have carried on board for his personal use. The surface of the aluminum disc should have engravings of the Boston Harbor as free-style line drawings sketched from memory. The sculpture should suggest a colonial map and an alchemist's table.

After a Northeaster April 16, 2007

I was walking through cold rain this morning, through what was left of the fierce spring storm that passed through New York City yesterday, and I thought about my five Boston walks. Once more, but with greater clarity and conviction, I realized that they are about creating an opportunity for revisiting the landscape, that they are about taking people back into nature and letting them loose. I hope they will lose sight of me at that point and get lost. Yes, they should lose me altogether. Because, just then, they might find their way, their path, back to nature and thus themselves.

I should be forgotten along the way, left behind or way ahead. The audience should wander aimlessly, rambling at their own pace. Then, after being lost in and found by nature, they should suddenly remember a small unimportant thing: me. They should only seek me like a squirrel that knows the way out of the forest. The audience should come out of this with experiences much richer than mine. My body is but an excuse to return bodies to nature.

April 23, 2007

I perform out of an unconscious necessity. It is what my body drives me to do. I am the background to its foreground.

The audience will be transformed if the performer is transformed. One requires the other; one is the result of the other. I seek to be transformed by places.

I am going to walk around Spectacle Island, whose shape has widened and risen through the toxic residue of human history. I want to trace its most recent shape with my steps. ICA members and unsuspecting park visitors may follow me. Nevertheless, I

will try to ignore them and become an animal in the landscape, eliminating the tiring body and soul dualism. If I achieve this, I will be there, truly there.

June 8, 2007

There is a wonderful quote by Robert Smithson. He says that there is a lot of talk about creating interesting new gallery spaces, but that he has never seen an exciting space; he does not know what such a space is. I have never performed inside such a space either. Gallery spaces feel so Platonic, as if they were non-sites. When my body is inside a windowless white cube, it feels disconnected, ungrounded. So far, I have not been able to engage in performance art distant from a meaningful site. So far, the spaces that my body responds to have mostly been outdoors. A gallery is nature, of course, but it tries so hard not to be that its anxiety drives away my body.

Sometimes I feel that clean, windowless, temperature-controlled white cubes should only hold prescription medicines and dust-sensitive hardware in storage. Nevertheless, I can envision using that hermeticism as part of the fabric of a future performance that needs a certain level of privacy, in terms of a one-at-a-time viewer. Indeed, I would feel different about hermetic white cubes if performers took them into thematic account, treating them as historic architecture.

Reflections after My First Boston Performance *July 6, 2007*

I have performed great sadness, desolation beyond consolation. Although I cannot say that the water carrier is happy, he has a certain energy that is unfamiliar to me. When I inhabited him before the first performance, standing alone in the empty gallery, beginning to create and hold his space, wanting to integrate into and emanate from the architecture, he was suddenly full of new life. Moreover, the wind, the pale blue cloudless sky and the beautiful seascape around him fed him enormously, so he was energized, like a finally liberated body. Something came from above and below, from all directions, and metabolized in him.

I had been concerned with the lengthiness of the performance (projected to last five hours), the group's commitment and endurance, and the timing of our two ferries (which turned out to be quite punctual). Nevertheless, I was committed to be slow. But a sailor came back from a watery grave, and his resurrected legs wanted to run! I had planned a meditative, even contemplative, slow walk. But my water carrier was a man with a mission, driven by invisible forces, impelled by unexpected winds, stopping at nothing until he walked the entire Boston waterfront, rode the ferry, perambulated Spectacle Island and gathered water!

There were short and long pauses, of course. When he arrived at the sandy beach, he embedded his empty vessel in the sand and let the waves slowly fill it by their repetitive rhythm. He did not draw water; Nature itself poured it into his bottle as a measured gift. And then, in an unplanned way, to reward those who had come thus far, practically jogging after him, he approached his followers and passed the precious bottle around to everyone's surprise, like a flask among thirsty sailors. People held the bottle up high against the sun, studying its microscopic contents. There were moments of true stillness too, as when waiting for boats to and from.

The many boats I encountered along the way spoke to me. Their names seemed to convey messages, unexpected poetic commands from the sea. I would close my eyes while on the ferry, open them randomly, and there would be a name painted on the side of a ship, telling me how to feel, what to do. It was remarkable.

The gravel path around Spectacle Island felt like walking on glass. I was barefoot from start to finish. There was much discussion about my bare feet prior to the event. The ICA finally allowed me to walk barefoot across its new floors at the last minute, but I had to grant the concession of wearing soles on the ferry because of transportation safety regulations. Being barefoot forces the body to feel a place, regardless of where the mind is. Barefootness grounds you instantly. The foot becomes a hand. One has no choice but to be there, paying attention to the road's texture, to surfaces that can cut you. Every place has a different skin, but our shoes do not let us feel it.

A performance needs to earn the respect of its audience, particularly when it is a public gesture, even as it also needs to elicit its own internal dignity regardless of audience. A public performance must develop a deep inviolable core; it must find both a compass and an anchor within itself. This double core is the result of the piece knowing itself, its vulnerable *raison d'être*.

Normally, after enacting a performance at a faster-than-planned pace, I feel like hiding under a bed for weeks. (Luckily, my bed resembles a very low Japanese bed, practically a tatami mat on the floor, so my mind cannot get away with this.) This time, however, my pace felt as if it was the speed the environment demanded from me that glorious summer day. Nature tossed me around. In fact, my expensive nineteenth-century costume (obtained from a costume historian in Chelsea) was shredded by the wind. I was practically in tatters by the time the first walk ended. So my costume will be torn to pieces one performance at a time. Although I do not think that I will arrive naked to the last performance in late September, I will certainly arrive in rags. Yet, that too seems appropriate. The character should slowly disappear until he is no more, dissolved by wind and water.

Reflections after the Second Boston Performance August 4, 2007

I have taken a break from writing to let experiences be processed at the unconscious and physical levels, to let Proustian memory take over, editing the superfluous.

I am increasingly aware that I have been creating a template. I believe that I started with 50 percent of the water carrier, accepting not-knowing as the way to finish constructing him and the performance as a whole. Each performance has been a laboratory for exploring, gathering, learning and making decisions about him. My curator has provided me with a unique opportunity not only to perform but, literally, to create in public. This allows the institution to not only be a place of exhibition, but a place of experimentation and making.

During my first performance, the water carrier tested his walking and learned how to walk. During the second, choreographed with teens-at-risk from the Boston Medicine Wheel project, as the walker unglued himself from the ICA's gallery wall, he awoke from his slumber unable to walk. I was unexpectedly physically paralyzed. My body was not responding. It was unexplainable. And yet, I did not feel any fear. I did not undergo a panic attack. I did not suffer from anxiety. So I simply began to take childlike insecure steps, descending four flights of stairs slowly, with my eyes closed, concentrating all my might on moving my legs, one at a time, guided by the uninterrupted, smooth flow of the staircase's cold metal railing. As I descended, I suddenly remembered that Jenny Wilson, my Bikram yoga instructor, always told us that *where the eye goes the body follows.* So I opened my eyes and timidly began to look ahead. My body continued moving tentatively until my eyes met the youth from Medicine Wheel. Unbeknownst to them, they began to teach me how to walk again. I imitated their steps and slowly followed their pace along the waterfront. They acted as my healers and heralds, so that by the time we reached the first of the harbor bridges we were supposed to cross, my legs were back.

Another remarkable aspect of this second Boston performance was my relationship with the ICA's new building. I knew that I wanted to emanate from the structure as if I were part of the architecture, like a column that frees itself from the building. However, it was merely a concept until then. My body did not yet know how to incarnate it. As it is said of Western mystical experience, all I could do was to bring myself to the divine fireplace, placing myself psychologically and physically there, as close as possible to the heat of the burning fire, actively waiting for the unknown.

During this second performance, I was able to put on my body paint and costume earlier, hoping to spend more time alone in the gallery standing against a wall, achieving internal silence for myself, generating silence for my viewers. That early morning, my being began to drift into the wall, it finally became embedded in the wall, disappearing behind the wall, floating up the wall, as if joining the metabolism of the building's body. My body was suddenly part

of its wiring, cables, beams and joints. I felt and saw them all as if X-raying the place. The building was like a young reptile, like a creature uncomfortable in its own youthful, scaly body, shifting enormous metal plates, rippling noisily and bumpily along its silvery skin. It was not a happy creature at that moment; in fact, it was furious to the point that I had to extricate myself from its inner life, circulating back into my body, fearing that its anger would become mine and that I would commence the performance angry. I had to conjure images of calming, cool, fresh water to block its anger, to detach myself, to try to return to the performance. Perhaps that is why I temporarily lost my legs.

After the second performance was over, I privately shared all this with my curator while removing my makeup in the green room. She remarked that the building had recently undergone very invasive maintenance procedures, and that she thought at the time that it was like a reluctant child having its teeth cleaned roughly. Perhaps my empathic body had become one with the lingering discomfort of the psychic body of architecture.

Water Cycle performance, digital image by Eduardo Aparicio, Boston Harbor, 2007

Third Boston Performance

During my third performance, on Georges Island, I did not expect to reexperience this secret relationship with the psychic body of a building. I imagined my body as a bridge between the ICA as a fragile twenty-first century cultural fortress, and Fort Warren, a nineteenth-century military stronghold. But as I looked at Georges Island that morning from the ferry and studied the looming structure, it became a prehistoric elephant in chains, practically roaring, barely suppressing its roars: an imprisoned ancient beast in pain.

I walked up to the fort's dark entrance, and my small hand fell on a little square created by four rusted iron dots on its massive outer wall. I began to walk the fort's perimeter, lightly caressing its surrounding wall uninterruptedly with the tip of my fingers. The walk took my body into and along a deep dry moat, now a shady cool green corridor. Sometimes the outer skin of the wall crumbled and fell at my touch, like the flaky skin of an old man with eczema, making a subtle crunchy sound. My wandering fingers discovered all sorts of salty stains and crevices along the way, as well as abundant miniature life, from lichen and moss to tiny spiders and insects that scurried away. I felt that my palm was calming, petting the beast to sleep, like putting a mastodon to nap. Carol Becker has said that my performances often have to do with reparation.

A sited durational performance belongs to a place and a people. Sometimes, however, it also belongs to its artist. Ownership is something that shifts constantly during its course, various moments belonging to various constituencies. The beginning and end of a sited durational performance belong to the audience that comes to witness the energy of the performer at its outset and his exhaustion at closure. The middle, after everyone has gone home, usually belongs to the artist. Ultimately, this shifting of ownership depends on a combination of factors: the presence or absence of an audience, particularly when participatory, thus completing it; the emblematic quality of historical or contemporary architecture as its grand stage or monumental backdrop, absorbing it into its archive;

and nature itself, from cameo appearances by pets and wildlife to the arc of time as punctuated by changes in light, darkness, heat, cold, humidity, snowfall, rainfall and dryness eroding the body of the performer.

The most cherished moment for the performer of a public, sited, durational performance can be when its entire audience has gone home (and they will, because it is too long for anyone to witness in its entirety), when a city finally sleeps and he has been left alone after hours of gesturing. Presumably, no one is watching, there is no need to act, if he was ever acting, so that all his defenses have finally dropped, one by one. He is vulnerable; he has surrendered. He is one with the site; he is the site.

My third Boston performance felt like it belonged to me. It started with families who followed me to the boat and later along the fortress wall, an army of little soldiers, of brave boys imitating me. (Adults could be terrified of me, but children were usually fearless.) I could not really see them, but I sometimes heard them talking excitedly among themselves behind me and would catch a glimpse of a small dancing arm or foot. (I later saw them in photos and laughed.) Although three of the boys and their father rejoined me toward the end, returning with me to the ICA, acting like miniature bodyguards, opening my way through the harbor's tourist crowds, the core of this third performance belonged to me. I was alone for most of the walk. After the first two hours, the families got understandably tired and went off to picnic. They left me alone with the fortified monster, with an old war idol, but it did not eat me. My fingers, however, ended up bruised and bleeding from the constant friction as they ran across the wall uninterruptedly for hours. It was empathic. In some cults, the gods need to lick a little blood. I think that the creature appreciated my bleeding. We were both bleeding.

That same Saturday night, I walked the Boston waterfront again, which was becoming very familiar and comforting. I felt that I was beginning to know and love it the way a child loves a secret path to another dimension only he can secretly access. That is the spell of

performance art: to manifest revelation in full public view, but in such a way that most think it is artifice, fiction. On the waterfront that evening, I trespassed a gated area and sat on a small, empty, private pier watching a family of wild ducks paddle by under the safe cover of night, the mother watching her ducklings feeding while solitary jellyfish slowly floated by like ballerinas on a black stage, dancing without concern for audience, or predator.

That Sunday, I traveled to Lovells Island, which I had never visited before. Lovells is known for shipwrecks. One tragedy involved a vessel sailing to Maine that struck the rocks in the dead of night. Even though the passengers survived, they later died of exposure, including young sweethearts found still embracing after death beneath the unforgiving shelter of a large boulder still visible today. Lovells was fortified during World War I. It took two boats and a friendly young captain to get there. Artist Anna Schuleit was there with her assistant. She gave me a tour of its ruined fortifications, which felt like abandoned Carthusian cells (I inevitably see monastic quality or potential in everything.) Upon entering the first enclosure, Blaine Anderson performed a spontaneous gesture that I recognized as the way to engage the site. The former batteries retain a lot of iron hardware hanging from their walls, and some can be manipulated to sound like bells by lifting the heavy metal loops and banging them against the structure. I envisioned a walk punctuated by bells tolling. It was what a performer strives for, these spontaneous moments of recognition.

Fourth Boston Performance

Even though I woke up that morning dreaming of giving away many gifts, the performance on Lovells Island was much harder than the others. There were more tourists than ever along the waterfront asking to take my picture. Some men insisted on giving me single dollar bills, but I chose not to respond. It was painful because I did not want to be rude. But I am not an entertainer. I do not perform to entertain.

Lovells Island was beautiful. The small group that followed me

kept perfect silence. We could hear all its natural sounds: the wind, the waves, birds singing, the buzzing of aggressive bugs (biting our pilgrims) and particularly the cicadas, which were wonderfully loud. I walked into each of the four batteries and "rang the bells." I transformed the rusty metal rings hanging along their massive walls into bells, lifting and banging them against their niches. They all rang differently, high- and low-pitched, strong and weak. I succeeded in briefly turning the footprints of cannons into cloisters. Inside each battery, my body walked toward the empty cavity where a cannon had rested, now invaded by trees. My body felt a lot of violence lingering around me. It felt a need to put out some invisible fire that was still smoldering.

After my body was done walking in and out of all of them, healing the place at some level, it moved away from the ruins through the bushes toward the beach. The day was extremely hot; the heat index was over 100 degrees. Nevertheless, the open beach was magnificent. I could see a lighthouse in the distance to my right. Once again, I gathered water at the shore, but this fourth bottle was harder to fill. It took several hand gestures and waves. I then walked along the beach back to the ferry. The sand was on fire; it was extremely painful. So my footsteps followed the anemic shadows of every patch of grass and bush straggling the way. The pebbles were no better; they were like burning coals. My bare feet have never hurt so much. Thankfully, the boat was on time, and its deck floor was soothingly cool. I returned to the ICA with the remainder of my brave group, which included Janine, who had generously come to Boston with much effort. My sweat-drenched costume was more tattered than ever. I was suddenly glad that there is only one more performance left because I will arrive looking like a sailor turned homeless beggar.

Last Boston Performance *September 2007*

My last performance, on September 22, was very gratifying. In many ways that last gesture was really the beginning. It was a welcoming by the city and the state, as Dr. Sally Snowman received me in period dress, smiling and waving a big white handkerchief

and an albatross feather from the dock as our boat approached. We disembarked, followed her, and she offered me tea on the grass outside the lighthouse keeper's home, out of charity. I felt that conservative Boston was finally holding my body in its bosom after all these journeys.

In addition, I was followed by a large group that included photographer Eduardo Aparicio, as well as choreographer Ann Carlson and video artist Mary Ellen Strom, whose collaborative work I love. I did not find this out until much later. During the performance, I only glimpsed at two inseparable and remarkable women following me along.

Sally could barely contain her excitement. In fact, she found it hard to remain silent throughout my visit. She would often nervously break into speech, whispering the history of one or another spot on her picture-perfect little island; this was her island of scholarship, after all. As we sat down to tea on her perfectly manicured lawn, I stared down at my porcelain cup while she looked at the horizon. I kept looking at the ground, wanting to be grounded, holding on to every last minute, knowing full well that this was my last gesture.

We rose, and Sally led me around her tiny lighthouse, leading me down to a beautiful dark rocky beach, where a crowd of cormorants curiously watched me gather water as Sally too kept a respectful distance. As during my first performance, I passed my bottle among those who had followed us to the rocky beach. They held it like a treasure. And for the first time in the entire cycle, I decided to break my silence, whispering into Sally's ear without anyone noticing. I thanked her in the name of all the drowned sailors, and she was visibly moved. She then walked me down a visitor's path back to the dock, where a US navy–operated boat approached with a large blue-uniformed staff that took many photographs of me. I climbed and held on to its railing while the island disappeared in a sea of mist. Back at the ICA, I deposited the last of the corked water bottles on its stand and disappeared through a door. It was done. We had built a water sculpture; we had walked on water.

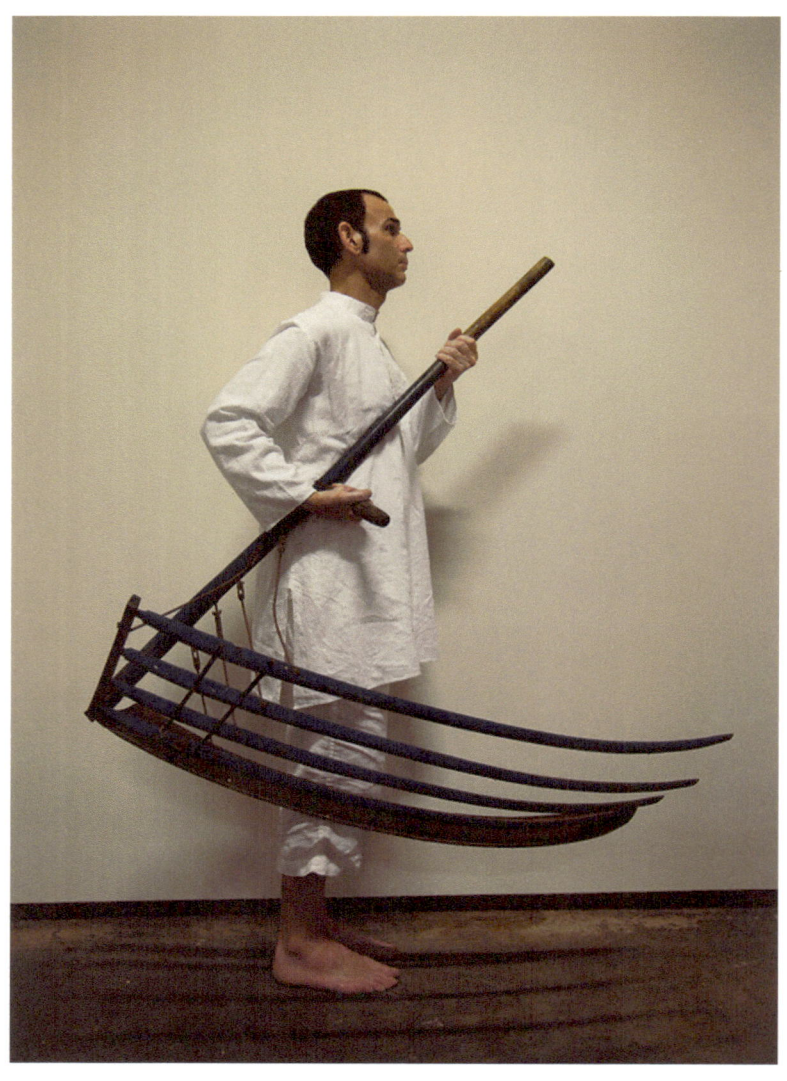

Farmers Dream performance, digital image with Aniko Safran, Salina, 2010

> *The body encounters itself when it is the only shadow on a landscape. At that moment, either it runs away, goes mad and dies, or turns into a stakeholder, if not a monument.*

Chapter Seven *Becoming the Land* [*Kansas*]

Body of Land [*Salina, 2003*]

I fell in love with the Kansas landscape because I grew up by the sea but feared it. Yet in Kansas I found a vast green sea in which I did not need to worry about drowning or being devoured by sharks. It was a comforting sea I could walk on forever, as if walking on water.

The mythical notion of the endless prairie is part of America's seductive power narrative, depicting an ever-expanding body (or skin?) without boundaries. Yet how can we see the land's true body without the mediating veil of human needs and fantasies? Human bodies have made so many horizontal and vertical claims on the Midwest, imposing an historically recent landscape created by hunger and utopia, from gridded farm areas to reclaimed tallgrass prairie areas. How can we make peace between the Body of the American Dream and the Body of the Land? I believe that it is the dream, rather than the land, that must be tamed.

The notion of shelter for an exposed American body is one of the most enduring Midwestern myths in our mainstream imagination: a little house on the prairie. Inside the twenty-first century homestead, there is now an urgency for storytelling stemming from fear of a disempowered future. True globalism could be created by a strategic network of tactful bridges for cross-fertilization across remarkable regions. But entrenched isolationism, fearing unfamiliar differences and loss of cultural identity, can elicit the most prejudicial and dated aspects of regionalism. Therefore, we need a revised enlightened regionalism. True globalism could be a rich tapestry of evolved singular regions. Much has been said about globalism in the arts. This presumes, however, that artists have passports that parachute

enlightened bodies across and into all spaces, understanding those communities; but that is not the record. Artists' bodies can colonize.

I approached my first trip to Salina, Kansas, from the point of view of the humbler agency of pilgrimage, a term that implies treating a site as sacred, the visitor pursuing insight, if not a vision, through communion. I first visited during a dry, hot August, when curator Saralyn Reece Hardy introduced me to significant elder artists, cultural-community leaders and creative citizens. Because I had her blessing, they welcomed me warmly and gave me their uninterrupted time. And I listened.

There were also road trips deep into one of the most stunning landscapes my body has ever experienced, into what was left of the open prairie—rides expertly led by hunter-rancher Norm Yenkey and octogenarian birder Marge Streckfus. Meanwhile, I was reading Willa Cather's *My Antonia*, one of my favorite books, and was constantly reminded of passages such as her description of the first trees planted by the homesteaders, of how they felt anxious about them and visited the saplings as if they were persons. They were the shadow on the landscape, and it struck me as the kind of environment that confronts individuals with what they have made of themselves; an environment that exposes and undoes all fantasy selves, that is only psychologically manageable if one has come to know one's deepest inner core—and emptied it. Saralyn described it as a "minimalist" environment that allows the body to fill in the blanks. But those bodies must bear something meaningful within themselves to so fill it.

From the minute my first site visit began, something remarkable happened. The place began to provide my body with gestures, not just to inform my gestures, but literally to form them, through citizens' concerns for their community's future as determined by the state of the land, local historical museum displays, historical landscape painting and the gridding of all reality, the created physical and psychic landscape. It was the kind of project that generates a visionary process at the crossroads of several disciplines, in which the artist's body must selflessly stand back and accept

the fact that the project is about another body: the Body of the Land. It is about embodying the accumulated gestures of the place. Therefore, the greatest accomplishment the artist's body can hope for in an interdisciplinary project such as this, integrating high and low culture, education, ecology and sustainable community development, is to negotiate and even give up the recognizable formal template of his gestural signature and absorb local forms temporarily, perhaps permanently, ultimately transforming himself.

I perform sited portraits of sited peoples. But secular, populated and unpopulated landscapes are a somewhat recent genre in visual history. Early pictorial practice was generated by rituals (cave figure paintings); by ancestry (funerary face masks); by political and religious ideologies (stages populated by royal weddings, births, deaths, coronations, wars and myths); by the likenesses of the powerful (portraits of courtiers and later commoners); and by capital (still lifes showcasing the trophies of abundance). There was some background landscape painting around real and mythical figures, or as a Renaissance exercise in architectural perspective. But commonly inhabited and uninhabited landscape rendering strikes me as particularly American, generative of a new and renewed pride of place.

When confronted with contemporary performance art, Midwestern audiences struggle with their lingering preference for the artisanal. Drawing and painting remain clearer skill-based exercises, the artist being an inspired individual who can transform something raw into something sophisticated and collectible. There is also an element of fear of the "familiar" unfamiliar: performance is very close to daily life and engages audiences in an inescapable way. Meaning is another challenge, because, in spite of subliminal advertising, we expect our art to be like television, devoid of metaphor. So, meaninglessness-at-a-glance can cause instant dismissal. Audiences often feel that performance artists are bad actors tricking them, unwelcomed magicians of disturbing secrets without narrative.

When studying Kansas on a map, the imperial imprinting of the grid as a counterintuitive organizing structure for the vast

grasslands that constituted the heart of the continent, regardless of topography, is shocking. But it ultimately determined the immediate future of the young nation, as Donald Worster writes in *The Inhabited Prairie*. Ironically, if modernity implies an updated visionary efficiency that sets up an eternally successful structure, the grid was not so modern for an empire so invested in modernity: it was a Platonic device simplistically employed to settle the country quickly, to turn every man into a ruler without regard for truly long-term consequences. Indeed, the minute it was set, animals and humans began to subvert it, crisscrossing it in every direction, because it had nothing to do with nature. But the grid would not be formally challenged until the advent of the railroad, which had to follow the true body of the land. The Midwestern landscape was made by and for a prescientific migrant male body that sought power through the land.

Thomas Jefferson first proposed the grid design, and Congress accepted his suggestion in 1785. The US Rectangular Land Survey was employed to civilize the wild American body. And while the cartographic American grid cannot be undone overnight, we can feminist-quilt it with circles, triangles and hexagons; we can reveal its Native American backing; we can consider its ecological redesign; we can walk it mindfully. Walking a grid is neither the shortest distance between two points, nor the most insightful. When I have driven through it, I have always felt slowed down and counterintuitively imprisoned at every corner. In walking-as-understanding landscape, we should follow streams, we should follow birds and deer, disregarding fences. Poet Harley Elliot once said to me that *to inhabit a landscape involves the dissolution of lines*. My favorite Kansas poet, Lori Brack, adamantly states that *landscape can only be understood by an unhindered body*.

Farmers Dream [*Salina, 2010*]

In May 2010, I choreographed a new site-specific, durational group performance titled *Farmers Dream* at the Warehouse, as part of my second artist residency at the Salina Art Center. My first 2003 residency resulted in the creation of five ephemeral installations

and nine performative photographs under the umbrella title of *Becoming the Land*. This 2010 performance was part of a larger interdisciplinary art project titled *Dreaming Kansas*, which also included the communal creation of a native field journal and interviews with bachelor farmers. All of this material can still be found at www.dreamingkansas.com.

Farmers Dream functioned like a Shakespearean mid-summer night's dream. I chose to loosely re-create a farming community in the Shaker tradition, men and women performing brothers and sisters, with all the flirtatious tensions of having handsome, healthy, young single people cohabitating. Although the performers were silent, an experimental poetic script was read aloud throughout the evening. Lori had recently come upon her grandfather's early twentieth-century farming journal, so I asked her to create a spoken text to perform and even expand on all night long, in whatever repetitive order she wished.

In addition, I brought in Utah artist Rosi Hayes to become the second voice of the performance, but a much more intuitive voice from the unconscious, purely lyrical. Unlike Lori, she could not speak words, but she was instructed to sing hymns, make birdcall imitations and other animal sounds, and improvise darker human sounds, such as the sound of a woman wailing alone at night. Lori and Rosi sat at the back of the stage while the performers sat right and left of a central picnic table covered with antique and vintage farm and kitchen implements. Indeed, the long, narrow homesteaders' table, rescued from a dilapidated cowshed, served as the boundary between the sexes. What follows are the performers' simple guidelines.

This is a barefoot practice, externally and internally barefoot.

I. Performers' Guidelines

1. Silence: Performers must be wordless at all times. We cannot speak, but we can make sounds, such as sighs, laughter, screams, groans and sobs.

2. Gender: A performer may indicate a "gendered moment," in which all the men or all the women must do something together.

3. Labor: Generally, the men will work separately from the women, and vice versa. But a man or woman may walk across "the gender divide" at the middle of the stage to engage the opposite sex in a noteworthy way.

4. Explorations: Explore our antique and vintage tools. Allow them to play with your body. In the same manner, explore the body through play with the tools. Tools give us a body, and archaic tools give us an old, unrecognizable body.

5. Speed: Tools will trigger unexpected gestures. Carry them out without hurry. Be slow; be very slow. Repeat a gesture many times throughout the night. Farming is about cycles: the mantra of predictability, the blessing of boredom. And be aware that while you are moving or working slowly, someone else might balance you out by being very fast on the other side of the floor.

6. Up & Down: You can run, climb, jump, fly, dance, walk in circles (forward & backward), and stand still impulsively, for no particular reason. It is a dream-like state.

7. Background: You can gesture during the silence, during poetry and during song. You are free to sit at all times. Poetry and song can affect you; in fact, they should affect you. Allow them to inspire and trigger gestures.

8. Railroad: If the train rolls by, you can turn around in your chair to watch it go by, or get up and walk/run to the big open door facing the street to watch and wave it goodbye.

9. Same-Sex Partner: If you need to use a tool with a partner, go to their chair and gesture to them an invitation to follow you. It would be nice to create groups of people using tools, particularly as we have several copies of one (two saws, four cutters, two milk cans, three watering cans and more).

10. Grace: Be graceful; always be graceful. You are being watched, studied and scrutinized by the public. There is a certain classicism to a barefoot group of people dressed in white, inside an old brick grain warehouse painted white, handling monochromatic wooden tools and white china.

11. Breathing: As noted before, you can sigh audibly; you can breathe deeply. Heavy breathing is very connected to hard physical labor.

Farmers Dream performance, digital image with Stan Cox, Salina, 2010

12. Rest: You can lie on the floor. The women have a quilt laid out in their area for the duration of the performance.

13. Breaks: Don't fight sleep. Go into the green room for coffee, tea, a nap, to splash cold water on your face.

14. Mirroring: Imitate each other. Feel free to imitate a gesture you see and like in another performer, right after they did it, or later during the night. Repetition and imitation are basic to farming. Learn gestures from others throughout the night. Teach each other.

15. Stillness: You can stand and do nothing. You can sit and do nothing. You can be a melancholic farmer. But be generous with the audience.

16. Dirt: It is okay if your bright whites get soiled throughout the night. In fact, I expect you to end in filthy whites.

17. Returns: After you use a tool, put it back on the table where you found it. As in a tool shed, there is an order, a place for everything, so we can find it again. The table is an installation, a giant still life. But if someone gets up and approaches you while you are making a gesture with a tool, give it to them at the end of your gesture.

18. Noise: Ignore chatting, children, dogs, traffic, drunks, skateboarders, etc. The silence of the performance can take it.

19. Two Voices: Experiment with the acoustics of the space. Keep writing and rewriting the text; keep exploring modulations of voice all night long. This is a laboratory for the body and the voice.

20. Stage Presence: Only two performers can take a break at the same time. We are a small company, so the absence of three would be devastating to holding the space. Therefore, be mindful of others when you take a break.

21. Classical: This is a Shakespearean early summer night's dream. So you can be surreal and do the nonsensical, like farming the concrete, watering the concrete, planting seeds in the concrete, etc.

22. Memory: These archaic tools give us old bodies. Feel what it's like to be in that old body. Seek your deeper emotions. Experience real emotion.

> *Genders perform for each other and, in their anxious shuffle, trip on themselves.*

II. Choreography Menu

The performers were invited to improvise, but I gave them this list of choreographed moments they could start with or draw from throughout the night if they ever exhausted their own ideas.

1. A woman puts on an apron and performs a task. A second woman puts on the same apron and performs the same task. And then a third mimics them.

2. Two or more women put on long-sleeved gloves and walk around looking at their hands as they hold them high, blocking the sun.

3. An angry woman arrives with a stack of white porcelain dishes. More women arrive. They are angry. They break some of the dishes, to their own surprise and shock. Some laugh out of nervousness, with relief. Others cry a little. Someone sweeps up the pieces and takes them to the town dump (a warehouse corner where we will dump our performative waste).

4. A woman works the water pump to fill a bucket and then sprinkles the floor and scrubs it. Spend the night scrubbing off and on.

5. A woman throws up a cloud of flour into the air, watches it fall slowly and settle on the ground and then draws with her finger (or a feather) on the ground. She walks away from it, leaving the

drawing. Another woman comes and cleans it up for her (destroys it).

6. A woman naps on the quilt while another reads next to her guarding her sleep, or eats.

7. Two women unfold a tablecloth and begin to work it in the air, many times, as if trying to smooth out the wrinkles before setting it down. A third runs in and out, as it rises and falls.

8. A man sneaks out a woman's glove and tries it on, puzzled. He puts it on as a sock. Perhaps he also dares to try on a small delicate apron.

9. A woman walks around showing the public the black-and-white photo of her sweetheart, hugging it in-between.

10. A woman works the water pump to fill up a watering can and then waters her garden, creating a round puddle within one of the pools of light on the stage. She can jump in it, like a small mischievous girl, or walk away from it. Another woman comes after her and mops it up. The second woman may be annoyed.

11. A woman gestures for all the women to get up, form a circle and run in circle holding hands. They spiral out of control and laugh, or they suddenly stop and laugh.

12. A man gestures for all the men to get up and form a circle. He motions to three, and they clap three times. They sit down.

13. One man plays the fiddle, and two men dance together awkwardly. The women dance together less awkwardly. It is important for the men and the women to visibly watch each other across the stage throughout the night, like looking across a field. Performers may put their hands on their hips, or rest them on the back of chairs, as if looking out windows.

14. A man washes his dirty feet in a tub. A woman washes her

feet in a tub. They dry them with towels. They can do it parallel, not knowing that the other is doing it in some other part of an imaginary farmhouse.

15. Three men open holes at the same time, spiraling the tools. The women imitate them. How does the same tool look when operated by a man versus a woman?

16. One man picks up the horse fly snap, untangles the leather, spreads it out (in the air, on the floor), and drapes it across his back. He plays horse and gallops around with it. He takes it off and walks away.

17. Women play with turkey feathers. They make mustaches and imitate old men. They tickle each other.

18. Yawn and stretch, for real. Use your sleepiness. Sleep (nap) in front of the audience. If you snore, we may awake you or let you snore as part of the scene and sounds.

19. A woman or man milks a cow using the one-peg milking stool. But you need to invite a performer to stand there, so as to put your head against their back or bottom to steady you.

20. A man hangs the bones of a cow around his head and stands still, eyes closed, arms down, like one condemned to death. A woman does the same.

21. A woman walks around with a sunflower, like a homecoming queen.

22. A woman rocks a bird's nest like a baby.

Post-Performance Thoughts

All durational performance nights hold a similar quality for me at their outset, as if I were facing a huge fertile valley stretching in every direction with endless possibilities: a valley of time to be traversed slowly, with relish, enjoying every step, never to be rushed, demanding a thousand pauses to look, smell, feel, think and not-think. The start of a durational evening is always an incredible internal celebration for me; I can barely contain my child-like enthusiasm—I am innocent again. It takes years to manifest such an evening for only one evening, like an old magician cooking potions in a secret chamber, finally achieving the temporary youthful embodiment of a much-yearned-for spell that will create an ephemeral reality.

I spent much of the evening plowing: pushing, pulling and carrying on my back an old, horse-drawn, heavy metal plow that made a rasping but tolerable sound when used across the concrete floor of the warehouse that housed our performance. I surrounded the audience with my slow plowing, before and behind them. I also spent much of the evening prancing like a child. I had not skipped since childhood, and I experienced a particular delight in jumping as high as I could with my adult body. It was circus-like. I totally surprised the audience (and myself) with this playfully humorous behavior. It was good to take a break from my seriousness.

Perhaps the greatest highlight of the evening for all consisted in the passage of the Union Pacific train. Our warehouse was located just feet away from its worn tracks, and I knew that the train would roll by late at night after loading up grain from one of the city's many silos. So I left the tall, wide, metal door to our warehouse open all night seeking this very moment. Thus, even as we were inside, we were also outside, practically on the street. Suddenly, we heard its haunting siren as it approached slowly. One of our performers ran out, saw the growing lights of the train in the near distance, and silently motioned the others to join him. The entire company of ten came out as the audience sat riveted, watching performance intersect with life. Ten barefoot performers dressed in white stood in a pool

of light waving at the train with their hands and handkerchiefs as it rolled by in slow motion. The conductor gave us a big dumbfounded smile, like one watching sleepers in pajamas come out of nowhere. He rang the horn in response. We were in Kansas.

After the performance, one of the many women who watched us throughout the night came over and told me that she had gone home that morning to make a traditional breakfast for herself and her husband and that for the first time in her life she had realized that she performed the same gestures every morning of her life—that her life was a performance of service, of duty and labor. She observed her own wrinkled, tired hands, her every repetitive gesture, and she suddenly gained an awareness that she had never experienced before. Another woman hugged me with tears in her eyes and spoke about performance as a medium that was so true to life that it was almost unbearable, because it was such an accurate mirror to loss and suffering, to the brevity of it all. Our performance was over as life is over. It began last night, seemingly interminable, but suddenly it was done, gone forever.

Speaking in Silence performance, digital image, Honolulu, 2011

Silence is not the absence of sounds; silence is the absence of distractions.

Chapter Eight *Body of Silence* [*Honolulu*]

As previously stated, I have developed the practice of creating a performers' manual when a performance project entails a group of artists and nonartists who need training. No matter the scale of the group, I create a manual they can read in-between our sessions together, sharing my vision of the piece, general observations about site-specific, durational performance art, detailed instructions (collective and individual choreographies), predictions and questions for them to consider, before, during and after.

Although I have an ongoing template for the manual, as there are signature gestural and thematic concerns that migrate from piece to piece because they are found in the human condition everywhere, each document is ultimately edited and newly informed by each site. The manual is always informal. I read it out loud before the group during our first meeting to activate the words, we discuss and annotate it extensively and after the piece is completed, I try to make it and all other project-related documents public through an accessible archive. I share parts of the Honolulu manual here as a performance practice field document. Sample manuals from other sites may be found online.

Speaking in Silence [*Hawaii, 2011*]
Selections from a *Manual for Producers, Performers & Volunteers*

Trust is both the foundation and the building block of public art.

Another ancient art was that of the diviners who revealed hidden things about the land, called Pointers-out-of-sandhills (Kuhikuhi pu'uone)... They were able to find things hidden away from the eyes of men... there were few such persons in the old days [but] there are none today... orators too have passed away.
 From *Hawaii Before Foreign Innovations, Ruling Chiefs of Hawaii,*
 Samuel Manaiakalani Kamakau

I. Introduction: ***The Right Silence***

Island: A body of land surrounded by water.

Islands are densely populated environments full of sounds from humans, birds and other animals, plus volcanic geology and the surrounding ocean. Human silence is defined not as the absence of sounds, but as the absence of human interruptions to consciousness, such as human chatter, unwelcomed music and machinery noise. We always seek silence with a purpose: to focus and work productively; to focus and meditate deeply; to focus on the needs of the self (rest and healing). There is no void in nature; nature is full of sounds. Thus, we edit sounds; we reject some and accept others. We actually seek the sounds of nature and we call them silence.

Can we carve out time and space in an island's dense fabric for this silence? What for? And what will we fill it with? In Hawaii, perhaps our silence may be filled with fragments from the histories of all the forces and sentient beings that have created its fragile balance. Therefore, we seek a fully conscious silence in which words enrich and deepen it. Right words are part of silence.

Speaking in Silence is a new, site-specific, public, durational group performance based on the cultural diversity of consciousness in the Pacific in terms of its indigenous, Christian, Buddhist and secular components, both in the islands and throughout the region.

II. Performance Synopsis: ***Right Future***

Speaking in Silence will consist of nineteen performers, alone or in pairs, alternating as public speakers and silent monastics, scattered for one day throughout twelve historic and culturally relevant sites across the city of Honolulu, humbly appearing at sunrise and humbly disappearing at sunset, a nonspectacular but public event. They will read from a common historical script in various languages, inviting viewers to find and follow them, revisiting the city, revisiting the past: healing the past so as to have the right future.

III. Production Observations

The project starts by forming a Project Production Team consisting of: 1. the choreographer; 2. the curator; 3. a senior producer; 4. the performers; 5. a volunteer coordinator; 6. representatives from relevant communities and institutions; 7. art students seeking field training; and 8. a public relations official. Roles may overlap. All meetings are open; everyone is welcomed to audit. The choreographer leads the group, reports to it and seeks its advice.

The tourist industry is filled with spectacles of native culture, so there is a familiar relationship to the performative. In addition, some cultural institutions present historical reenactments, particularly around artisanal labor. We will form an ephemeral company consisting of graduate art students from the University of Hawaii, professional artists, museum members and people from the community at large for the daylong, sunrise to sunset performance. Performers will participate in training workshops at the museum. These training workshops will try to accommodate everyone's working schedule.

The performance will be found across twelve Honolulu-area sites. Performers will be matched to locations appropriate to their personal histories, skills and interests. Locations currently under consideration are:

Iolani Palace, the Hawaii State Library, the Hawaii State Capitol, the Hawaii State Museum, the Mission Houses Museum, the Honolulu Academy of Arts, Oahu Cemetery, the Historic Chinatown District, Aloha Tower, the Waikiki Natatorium War Memorial, the National Memorial Cemetery of the Pacific at Punchbowl and the Foster Botanic Garden.

IV. Performance Choreography: ***Durational Dynamics***

I try to envision the performance, moment by moment, for my performers. It is almost like conjuring up a daydream, like predicting the future throughout the process.

Two foundational quotes:

As performers, we are not afraid of placing audiences in a zone of healthy discomfort, of not-knowing. That is the ground for questioning, the beginning of knowledge.

As performers, do not give in to apologizing for the fact that "nothing happens." It would be like apologizing for time, the seasons, the arc of the day. Of course, at an unseen level everything happens, if you experience the purity of time [no-time], the details of place, collective memory; your deeper self [no-self].

A. **Inhabiting Silence**

Can you be the body of silence?

On the morning of the performance, before sunrise, you will dress monochromatically in red (a favorite national color dating back to pre-European culture) and then depart for your assigned locations. Select a private quiet space where you can dress without clutter, distractions or disruptions. The performance does not begin on the street. The performance starts the minute you begin to dress, the moment you begin to inhabit the persona of a walker. After you dress, look at yourself deeply in a mirror. It will be the last time you see yourself for ten hours. The next time you see yourself, your body will show the passage of time, and experience. Ask yourself: Will I be any different after this? How?

Plan for who is going to see you first. If family, friends and neighbors are going to be your first witnesses, prepare them for what they are going to see, and ask them to respect your silence. You are to remain in silence from the moment you dress to the end of the performance. But remember: silence is not the absence of sounds; silence is the absence of distractions. So, it may be appropriate to ask for help, or to answer a question that helps your performance. There is a right silence and a wrong silence. One is about punishment, and the other one is about generosity.

It should be silence by mutual consent. We are silent because we are generous, because we want to listen to everything and everyone. Let generosity protect your silence throughout the entire process. Think of allies rather than adversaries. Recruit your loved ones into your silence. Make them responsible for your silence, the loving guardians of your silence. Your silence is your most precious contribution to the performance, to your audience. Your silence gives you a body; your silence gifts them with bodies.

If something unexpected happens, you have a choice: you can let it annoy you and spoil the moment, or you can previously have decided that regardless of what happens, this moment is unique, precious, fleeting. This moment belongs to you. This is a moment of consciousness in which you are crafting your life the way you want it to be, even as you must be generous at all times. So you are going to take a deep breath and flow. Flowing is your mantra. You have decided that nothing is going to disturb you, that nothing is going to rob you of your inner and outward peace.

You will come from nineteen different points in the city. You may use public transportation, have someone drive you there or walk. But regardless of how you get to your assigned location, you will do so in silence. If someone drives you, they must drive you in silence. And you must be dropped off a few blocks from the performance site. No performer should be seen stepping off a car at a performance. Regardless of how you are transported, you should all arrive by walking slowly. Walking as the body's approach is the way the body understands the breadth and depth of a place, the way it best takes it in. All other forms of entrance limit the body's experience of a place. Walking is always the most wholesome entry for a human.

It is important that there be a sense of journeying to the place for the performer, creating for yourselves an emotionally felt arrival. All will arrive in silence to watch the sunrise at their individual sites, site operating hours permitting (if applicable). There will be a minimal repertoire of gestures, such as hands down, crossed hands, etc., to be developed by the group during training.

If you are walking to your site, please make sure that you plan the time that it will take you to walk slowly through the city, without rushing, without hurry. Trace the walk days before, timing yourself. And remember that when we are nervous or excited, we tend to walk faster. Make sure that the distance between your starting point and the gathering site is manageable. Do not exhaust yourself when the performance is still so young and you have twelve hours to go, regardless of your ability to take breaks throughout the evening. If you have chosen to walk "a public route," in terms of a historical route that may be followed by the press with cameras, please remain in focus; do not let them erode your concentration. If someone gets in your way or even tries to stop you, slow down, stop if you must, smile, but walk around and beyond them in silence. You are not an entertainer. You are a walker, an embodied metaphor. Those who follow you can explain to the curious what you are about, inviting them to follow you too, or to come see the durational performance later.

You may walk alone as a solitary walker, or you may invite as many people as you wish to follow you. That is your choice based on the kind of walking experience you want to have. Please be sensitive to your potential followers, making sure that you explain to them that following you will turn them into performers, because people will look at them following you. Your followers will expand and complete your walking performance.

Depending on from where you approach your site, you may begin to see other performers in red simultaneously approaching it. It is up to you to catch up with them (though you must never rush) or to approach the site alone. You may plan ahead of time to meet with another walker along the way, arriving as a pair. But consider the logistics of this meeting because one of you may arrive at the planned location (street corner, etc.) before the other. So plan what you would do if that happens, in terms of standing still until your walking partner arrives.

If you leave meeting and walking together up to chance, consider whether you would accept the company of a performer who unexpectedly approaches you along the same route. Generally

speaking, I recommend walking some part of the journey alone. Give yourself that experience, even if later you meet up with someone. It will make the meeting all the more comforting, after having experienced some solitude. Solitude is not the same as loneliness; solitude is an important performative experience through which one can discover much about the site and self.

Once you have settled at the site, either standing or sitting, and have been in silence for an unspecified amount of time (according to each situation), you will read out loud from your common script, alternating between silence and reading until sunset. Each performer will carry a script in book-like form. All performers are free to pause as often as they wish and to read as long as they wish. Each site (and audience) will trigger a different rhythm of activity and rest. This unpredictable selection of words, and repetition of words, is extremely important, because it is your way of reacting to the weather, the site, the people, the lack of people and your own emotional life. And this will mean that although all of you read from a common script, each one does so in a completely different way. The public will find you through maps that will be available at all the sites engaged, so that they can find you throughout that day.

B. *Endurance Considerations*

Listen to your body: from now on, always listen to your body. If you are ever in doubt during the performance, slow down, pause and then ask your body: what do you need; what do you want? Where do you want to go? Because a durational performance engages in endurance of body posture, reading voice and bodily needs, there will ideally be a group of volunteers per performer who can help you access water and food, and escort them to a bathroom break during the duration of the piece. Performers will only be located in sites that have access to restrooms.

You should try to experience stillness. Stillness is important, because it evidences your oneness with the site, its landscaping and architecture, your integration into place. It is part of the bones, the

skeleton of the body of the performance. Your moving and reading, on the other hand, evidences the metabolism of the city, your social contract within it, as well as the blood flow of the body of the performance.

In a durational performance, no matter how much you plan the choreography, there will be an unpredictable individual choreography-within-the-choreography: the unknown, the unexpected, your active imagination, the unconscious, the being-in-the-moment, sensitive to your thoughts and emotions as they make you flow, pause, flow, stop some more, organically. Surrender to it; do not be a robot. When overtaken by an unexpected memory or emotion, stop for as long as you need to, or find a passage in the text that conveys it, and read it out loud, or whisper it. Do not hide under poses, marching, touching. Do not pretend.

The entire performance consists of a common set of very simple and clear rules and an austere visual language, but it is left to the individual to make choices. It is the difference between a prison and a monastery: the first is a place of punishment; the second is a place of freedom, both within walls. They can be the tall walls of a horizontal fortress or the deep walls of a vertical well.

We are nothing but the voice of a place. We are not dancing. We are not acting. We are simply taking the stuff of our daily lives and calling it art, turning it into art: the way we wait, the way we walk, the way we stop, sit, read, breathe, gesture. It is a terrifying thing to do. It is a very simple thing to do.

We are generating an experience that is not rehearsed and may never be repeated. Do not be worried if the performance dynamic takes a while to sink in, come across and work. The performance is twelve hours long. Let it settle into itself; let it find its form; give things time to work out, like slowly peeling an onion.

A durational performance based on walking, being silent, reading and stillness does not have a narrative arc with a dramatic climactic peak and post-climactic drop. "Nothing happens" in this

performance. It is about a body walking nowhere. But as the body is sited over time, the place gets deeper. The site becomes a well. The horizontality becomes a verticality, a gorge, a cave, an abyss. If you surrender to this repetition in place, the place opens up, outside of you, inside of you. You open up. Monasteries are places of repetitive manual labor, of simple industry, so as to allow the mind of monks and nuns to be free to wander, hover, fly, fall, sink deep, get lost, empty, find, be found, be filled.

The only things that will visibly happen, other than the passage of time on your dress, on your body, will be nature and the city. The sun will climb. Clouds will drift by. The temperature will rise. Car traffic will rise and fall. Viewers will come and go. People will walk their dogs in the morning, in the late afternoon. House lights will be turned on and off. Eventually, the sun will begin to come down and set. Nature and the city will be the outward signs of the passage of time.

Please consider what you are going to do with your mind. The body is sited for twelve hours, but what does the mind do for twelve hours? Yes, there is a text that you may read at random, according to your intuition. But that text alone will not occupy the mind fully. Therefore...

1. Do you begin to harvest memories of waiting, memories of loss, memories of mourning, memories of sadness, memories of pain, memories of joy, weeks in advance, waiting to unleash them at the start of the performance within yourself, on yourself; to experience, explore and feel them without restraint?

2. Do you begin to harvest many issues, or a single issue, weeks in advance, to consider them/it during the performance, from every possible angle, like a long, profound, complex meditation?

3. Do you patiently tell yourself the entire history of your life, in the greatest detail, like someone at the point of death? Do you want to die during the performance, without anyone noticing, imperceptibly, and be reborn at closure, without anyone noticing?

What are you seeking from this experience? Do you spend the performance critically remembering and reviewing your autobiography so far, rejecting parts, rewriting parts, giving it a different ending?

4. Do you spend the performance looking at this site, at this place, knocking at its doors, ripping the fabric of reality as has been constructed so far: unpacking, decoding, dismantling and then, reconstructing, rebuilding, re-creating it anew?

5. Do you spend the performance trying to see nature through the human veil, seeing the sky, the clouds, the sun, the moon, the stars, the mountains, the wild life that crisscrosses the city at all times (but most specially at night)? Do you seek waters buried underneath?

6. Do you spend the performance in mental conversation with someone you loved but is gone, or still here but unavailable? Do you spend the performance talking with lovers, demons and angels, or ghosts?

7. Do you spend the performance asking forgiveness from everything and everyone you have left behind, abandoned, dismissed, rejected, trampled, hurt, betrayed, abused, molested, tortured, damaged, killed? Do you spend the night forgiving everything and everyone who has left you behind, abandoned, dismissed, rejected, trampled, hurt, betrayed, abused, molested, tortured, damaged, dead? Are you performing restitution, retribution, repair, healing? Is it a performance that presents the evidence of many crimes, or of the crime of crimes?

8. Do you spend the performance emptying the mind of everything and everyone, breathing deeply, breathing lightly, just breathing, letting thoughts come through like waves, washing away, like tides, returning again and again to the empty mind? Do you reach a no-mind no-state?

9. Do you spend the day in happiness or joy? Do you know the subtle difference? Do you celebrate fulfillment?

Please consider the mind. What are you going to do with it for twelve hours? Give it a task. Give it no task. But plan the mind.

If strong emotions surface, allow them to flow. If you feel sadness, if you feel like crying, if you feel rage: allow yourself to feel. If your crying feels like it might become uncontrollable (sobbing), consider taking a break for as long as you need to. The same if you suddenly feel like screaming, running, jumping, shaking, prancing, cartwheeling, dancing. But if this is something you can contain without repression, without doing violence to your body or mind, remain in the performance and experience your internal weather patterns with humility. It is important information about your deeper self that you may not experience every day. As for others, if you see someone crying, let that performer be.

Speaking in Silence performance, digital image by project volunteer photographers, Honolulu, 2011

This is not, strictly speaking, a "pioneer endurance" or a "warrior endurance" piece. No one should get competitive about the amount of breaks they took during the piece. There is no price for taking no breaks. You are free to take as many breaks as your mind and body need. But in order not to disappoint yourself, ending up taking many more breaks than you thought you would need (because we often have high notions of our incredible endurance), I recommend sleeping as much as possible the night before. Try to take the day off, or work only half a day. Some people try to practice water rationing and fasting days before a durational performance, making their bodies ready for a long journey through a desert. But we also want to avoid fainting spells due to dehydration or low blood sugar, even as over-hydration is destructive of your performative focus. Please don't faint.

When you take a break, sustain your silence. Do not break it by chatting with others (the public, friends, family). You will have the rest of your life to talk about this brief moment. Do not be too quick to analyze, to dissect it. Let it be. If someone asks you a question trying to be helpful, just make a nonverbal gesture of yes, no, or thanks. If others are speaking, stay at a distance to protect your silence. And if you are nervous, anxious, about being so exposed, please breathe deeply and calm down. There is no failure other than not listening to your body. And if someone forces you to break your silence, be generous and do not resent that person. Just go back to it. Sometimes the best solution is what children do: sit quietly and close your eyes. Pretend the way that children pretend. Pretend that you are alone. Do not fight sleep. Do not start falling asleep on your feet. Go get a caffeinated drink, or take a catnap. Or go home. You can always come back later.

Photographers documenting our performance with video will receive guidelines on how to document it from the perspective of this particular practice, in terms of the silence and solitude of the individual performers, usually documented from the back, to protect their identities, to avoid consuming them. Performance art has a very rigorous set of documentation parameters. The performer is not the destiny of our attention, but a sign pointing to

landscape, or some issue. The documentarians should never distract a performer, nor be in the way of the public. Those documenting the performance should not do so from their point of view (consumerism), but from the point of view of the performance (contemplation). Not everything needs to be documented.

Please tell your family and friends to exercise visual discretion. Just like you would never take a photo inside a theater, during a play or dance on a stage, being outdoors does not mean that we can be visually violated. The nature of performance art when public, durational and collective, is that no one can actually experience (or consume) the entire piece either in length or area. And so, a durational piece will belong to different constituencies along its daylong lifespan: it will belong to the public, to the performer, to the site, the weather, the passage of time, the text, history and myth-making.

As the day unfolds, as the hours roll by, go deeper. Explore the space more and more. Feel free to pause where you have not paused before, to look out from where you have not looked before. If you have a performance partner, try to walk with the other performer, to experience their steps, speed, slowness, pauses. Be still with them. Walk or stand in solidarity with them. There is plenty of time for solitude during the day. But make sure that you also experience solidarity.

You will follow the natural progression of sunlight. At closure (in this case, sunset), you will walk away and disappear silently across the city. You will return to the site where you started from that morning. The piece thus commences and ends humbly, unspectacularly, maintaining its integrity as something substantial but ephemeral, not to be consumed but only profoundly experienced.

Please plan the end. If you live far away and know you will be unable to walk home after a long performance, make plans for public transportation, or for someone to pick you up at some point along the way, several blocks away from the site. As stated before,

no performer should be seen getting into a car at a performance site, breaking the fiction (or the reality?) that you/we have labored so long and hard to weave. If you can walk home, enjoy the walk, particularly if it is cool. Perhaps you wish to walk away with your partner performer. But please remember that you have been in silence for hours. Yes, you have been reading, but that reading has been part of your silence.

C. **Personal Closure**

So, please consider your *first voice*:

1. What are going to be your first words? What do you think they are going to be?

2. Who are you going to speak to first? Can it be anyone, at random? Should it be a special person in your life?

3. Would you like to end your silence with a ritual?

4. Would you like to preserve your silence a little longer? Would you like to go home to eat in silence, and go to sleep in silence, waiting until later to begin to speak again?

5. What does your voice sound like after not hearing it for so long?

This silence belongs to you. You conjured, nurtured and sustained it. It is for you to break it, stop it, end it, not for others to terminate it for you. Consider the end of silence…

Babel Is an Island *Hawaii Post-Performance Notes*

Every site-specific performance project turns me into a scholar of that people and their landscape. In the case of Hawaii, I concentrated on its pre-European history and early colonial history. Then, I jumped to its Kamehameha dynasty, studying its constitutional monarchy, the Victorian autobiography of the last British-styled ruler of Hawaii, Queen Liliuokalani, deposed by a

coup orchestrated by American businessmen, many of them the children of former missionaries sent to Hawaii to convert its native population to Christianity. I concluded my readings with young Princess Victoria Kaiulani's biography. Women of all cultures, classes and races, dead and alive, through their admirable lives, work and words are the unacknowledged gatekeepers of most sacred and secular places. Such women have always been my best guides into the depths of place.

When I began to research Hawaii hoping to create a performative text, I came across the following:

If a group worked together to compose a chant, the leader would ask each composer to give a line. If there were 80 composers, the chant would contain 80 lines, and these would be combined into a single composition. The chant might be delightful on the surface, but might have hidden meaning… Most [hearers] would not catch this [secret] meaning and would see only the pleasing picture.
 Hawaii Before Foreign Innovations, Ruling Chiefs of Hawaii,
 Samuel Manaiakalani Kamakau

This inspired me to try selecting readings in consultation with various academic and grassroots community scholars. University of Hawaii art students in the performance workshop would also contribute texts. The readings need not be long. Efforts would be made to match readings to the sites, so that there were historical and/or thematic connections. Literary forms would include journals, newspaper articles, letters, e-mails, biographies, autobiographies, essays, short stories, novels, poems, dreams, visions, songs, sounds and oral histories (anecdotal accounts, past and present).

Ideally, the common script would be read in various languages: English, Hawaiian, Japanese, Chinese, Tagalog, Portuguese, etc. They would be the languages of the various groups that have inhabited Hawaii since human intervention. But after collecting texts from my readings, colleagues and performers, I decided to use the *New Pocket Hawaiian Dictionary* by Mary Kawena Pukui and others, published by the University of Hawaii Press, recommended to me by a representative of the Kamehameha schools.

The history of Hawaii is the contested history of many peoples, still hurting as an adult betrayed by childhood friends. My performers did not have the knowledge or time to contribute enough. Their stories were often the stories of whiteness, old and new, island-born and newly arrived. Most if not all sought something from the island paradise, from its all-year-long summer weather to secret healing. And although those accounts were sincere and valid, I had a commitment to the more unknown and ongoing history of the Hawaiian, mixed native people. So I decided to plunge into the struggle as symbolized by the ongoing tensions between the language of the native people of Hawaii and the language of the annexationists.

We get to know and organize reality through words. Words have a way of creating further realities within reality. Words call and name; words name and call. Languages are like geological strata, ancient languages substituted by conquerors' languages, again and again, whether conquering by political aggression or economic and cultural influence. Ancient languages bear rich subtleties, particularly around flora, fauna and weather patterns. If we go to another country, a non-English speaking country, we must learn their language to understand their reality, certainly to navigate their space; to survive. But people move to Hawaii and do not bother to learn its language. So I decided to turn my performers, my public monastics, into students, translators and advocates of the Hawaiian language for one day.

In the end, my performers were aghast when I selected the Hawaiian dictionary as their text. Many were very disappointed that their selections were not being used. I even feared a mass exodus and was prepared to downsize the piece to one (me) if necessary. But they ultimately trusted me and accepted what some perceived as an abruptly harsh decision. Some of our relationships were never the same again, which was heartbreaking, even as some relationships improved. In the end, some performers spoke words out loud at random, as inspired by the moment, while others remained in silence all day and simply carried the dictionary with them as a mysterious, red, cloth-bound little book.

Sadly, even as I tried to affirm native culture, there was distrust among the advocates of native culture to the end. I understood this, because a betrayed people will not trust an outsider overnight. But it was still a heavy burden to bear even as I worked zealously on their behalf. I am not made of stone. In fact, my strength resides in my vulnerability. Distrust is something that has been a constant challenge in my site-specific practice, whether in Cuba, Hawaii, Utah or Kansas. Sometimes it is an initial wall I break through, in a public or private dramatic gesture, or a wall that slowly dissolves as I work on. Sometimes it is a corridor, a labyrinth. Regardless, in choosing to be an itinerant artist, I am always the outsider who must prove himself. Of course, some people's anger is ancestral, so, no one project will heal them. And some individuals' personalities are built through anger, and without their anger they would be lost and not know who they were. But I keep trying to dispel distrust. Indeed, much of the healing quality of the work resides in generating trust.

During the process leading to the performance, I was lucky to be adopted by four very different native women artists who gave themselves the mission of providing me with culturally grounding experiences, from ritually dipping in the Pacific Ocean as a cleansing rebaptism, to taking me for a walk through the forest to the ruins of one of the houses of a king. That walk was the most memorable of all such immersion experiences. The sun was going down so we walked briskly through an uphill sea of green. All throughout the climb I felt as if the forest were singing at the top of its voice high-pitched, happy welcoming songs. We arrived at a clearing where suddenly a dark, looming, ruined structure stood like a tired monster. It was made of lava stones. My companion began to chant an invocation as we approached. She said a special prayer upon arrival, and then we entered. My body immediately began to walk around the site counterclockwise. The footprint was magnificent. My friend said that it was called the House of the Singing Snails.

My last experience in Hawaii was visiting a group of much revered ancient stones on the beach, currently surrounded by a circular

iron gate. I approached them with another friend, a healer, but he left me alone, standing at a respectful distance so that I would experience the stone circle privately. My body approached the rock bodies reverentially and, as it did, they all turned, they remained still but simultaneously turned invisibly. I felt that they were like seated petrified mollusk warriors, waiting for a call too long in coming, sleepy but still eager to stand up and reclaim the nation. They looked at me with haunting octopi eyes, and no sooner had they glanced at me in mutual recognition then did they turn their eyes away back into an ancestral sleep, acknowledging while being acknowledged. The body, young or ancient, material or psychic, forever seeks to be respectfully acknowledged.

Walker's Coat from the *Grass Circle* performances, digital image, Skowhegan, 2009

> *The increasing linear intricacies experienced when walking deep into Islamic mosques express the gradual-to-total psychic experiences the walker is moving through.*
> Jawaher Al-Bader, architect & former student

Postscript *Leaves of Grass*

In gathering material for this book over the past five years, I had to make very difficult choices. For example, this text does not include my *Awaiting* project in Salt Lake City. That durational performance ran from sunset to sunrise and included forty performers, almost all Mormon, ex-Mormon and gentile women. *Awaiting* took place in front of the Utah State Capitol building with an epic snowy mountain backdrop. The performers spent a cold windy night climbing and descending the Capitol Hill steps, transforming them into a Jacob's Ladder, embodying human yearning and collective waiting. It was based on the premise that there is no waiting in nature, that waiting is a human act, a taming act. We domesticate animals by teaching them to wait. The performance made the front page of the city's major newspapers that morning and was declared the state's most important cultural event of 2010. There is a website for the project (www.awaitinginsaltlakecity.com) and two published journals: *Inheriting Salt* and *Deseret Days*. Nevertheless, I believe that my work in Utah is not finished: I hope to stage two more performance projects there in the coming years and eventually gather all this documentation into a single large publication.

23 Summer Mornings

I was resident faculty at Skowhegan School of Painting and Sculpture during the summer of 2009. It was Linda Earle's last summer as director, and there was a tradition for faculty to devise a participatory project in his or her area of art practice with the summer residency fellows. Thus, I began a series of weekly conversations about performance art in my cabin by the lake.

In addition, I was struck by the beauty of the upper campus, particularly during early morning. The lazy sunlight was golden, and the emerald grass was covered with diamond-like dew. That spring, at an antique fair in New York, I had found a long, vintage, green military coat made of water-resistant heavy canvas, and I instinctively brought it with me. I thought that it would make a great gardener's coat. Once in Maine, I had unearthed a beautiful piece of white marble from my garden. I had also brought a small pocket watch that had belonged to my mother. I kept all these materials in a studio in the woods that Linda had provided for my use.

One day, I rose at sunrise, silently walked over to my studio, stripped and donned the coat and, carrying the stone in my hand, my mother's watch hidden in my pocket, I walked to a fenced meadow behind the library building. I laid down my stone on the wet grass and began to walk a perfect circle very slowly, backward and counterclockwise. As I did, I emptied my mind, focused on my careful slow steps and kept the stone at the edge of my right eye at all times. I had discovered that if I tried to walk a circle without having a center, the circle would turn imperfect. But if I somehow marked a center and kept it on view at all times, it would turn out beautiful.

After I walked for about half an hour, I stopped, checked my pocket watch, walked over to the center of the circle, picked up the stone and headed back to the studio in the woods. I changed and returned to the field, now in bright daylight. The sun was quickly burning the morning dew. Nevertheless, there it was, my drawing: a circle traced in the grass by my naked feet. It was lovely and mysterious. It was as if someone else had drawn it, not me.

I then issued an invitation to all Skowhegan staff and participants. I wanted to give over my performance to them. I wanted others to continue performing it for me, enriching the experience. Therefore, I met with twenty-five or more artists and presented them with my proposal. We met a second time for training, which consisted on a simple set of instructions and walking practice, and worked out a daily morning schedule unto which they signed on. Afterward, for

twenty-three mornings, twenty-three artists, one at a time, with no audience, with me as their only witness, walked over to my studio in the woods and repeated the ritual. Nevertheless, my witnessing was hidden. I hid inside the library and photographed them through a window during the first five minutes of their walk. They never heard or saw me. (At the conclusion of the project, I gave them copies of the images for their portfolios.)

Over the next few weeks, rain or shine, hot or cold, more and more grass circles appeared in the meadow. Some were very thin, as if traced with twigs, and others very wide, as if performed by trucks. Some were very small, almost childlike, while others were enormous, practically gigantic. One could tell the focus, one could read the concentration of the walker based on the size and width of the circle. In addition, the circles were also affected by the speed and weight of the performers. Some performers hardly left a trace at all, as if they had floated, as if they had hovered over the grass. Others left deep imprints. Regardless, after each performance, I would visit the studio in the woods and collect the leaves of grass I found in the basin where all the performers washed their feet. I later gathered them in a glass vial that I keep to this day. It was good to give away the gift of performance.

Meadow Drawings from the *Grass Circle* performances, digital image, Skowhegan, 2009

Singing

Some speculate about approaching dystopias and apocalypses filled with zombie and alien performers. I prefer Eckhart Tolle's revisionist approach that the true meaning of the apocalyptic metaphor is not fire and brimstone, but the end of our blind enslavement to the aggressive, corporate, distracted, insensitive consumer race. It is about the beginning of our life in nature, in timelessness. So this sited body, these public visions, this silence, stillness and walking practice as performance art is the medium for the end of time.

However, unlike Walt Whitman, I write but do not sing a song of myself because I have never been seduced by my own myth. I weave a myth but establish distance because both are illusions: the myth of me, and the I. Does individual consciousness survive the recycling we call death? I do not know. So, I exercise detachment not only from my myth, but also from my so-called self. Everything is performance: the painter and the painted. All is performance, and it is humbling. Indeed, the humbling performance of so-called humanity's end may be like the humble performance of our ancient beginnings. As I conclude the performance of this text, I look forward to the humbler performance of our post-humanity in Nature.

About the Author

Ernesto Pujol is a social chgoreographer and writer. He is best known for designing performances as "psychic portraits" of diverse global communities under threat. These have taken place as empathic, durational group experiences, free to the public, performed by citizens of place as sited-peoples vulnerably performing their own complex lives. Pujol is also a committed educator, founder and director of *The Listening School Project*.

www.ingramcontent.com/pod-product-compliance
Lightning Source LLC
Chambersburg PA
CBHW041608220426
43667CB00001B/2